# MECHANIKA

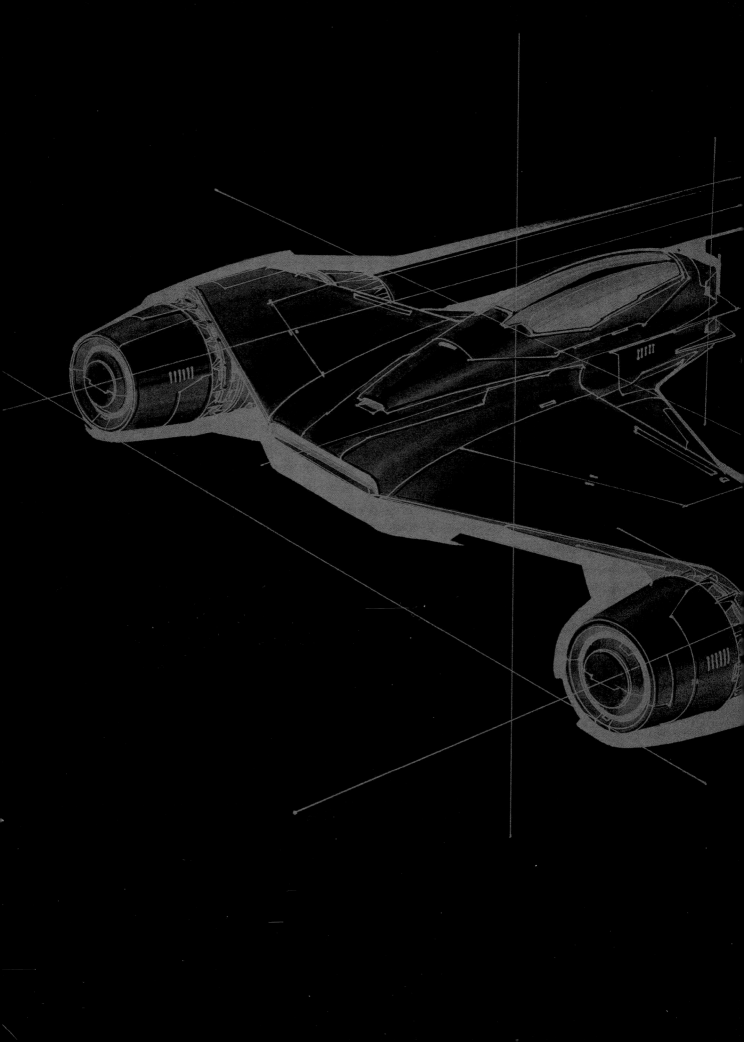

# MECHANIKA

## CREATING THE ART OF SCIENCE FICTION WITH **DOUG CHIANG**

**IMPACT**
CINCINNATI, OHIO
www.impact-books.com

Doug Chiang has worked in film and television production since 1986, earning an Academy Award, two British Academy Film Awards and a Clio Award. As a film production designer, he has worked on *The Polar Express* and *Beowulf* and the 2009 Disney film *A Christmas Carol*. Chiang was design director for the *Star Wars* prequels *Episode I* and *Episode II*. He has written and illustrated several books, including *Robota*, which he created and co-wrote with novelist Orson Scott Card. Chiang is executive vice president of ImageMovers Digital, a Walt Disney company.

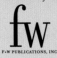

by a reviewer who may quote brief passages in a review. Published by IMPACT Books, an imprint of F+W Publications, Inc., 4700 East Galbraith Road, Cincinnati, Ohio, 45236. (800) 289-0963. First Edition.

Other fine IMPACT Books are available from your local bookstore, art supply store or visit our website at www.fwpublications.com

Adobe product screen shot(s) reprinted with permission from Adobe Systems Incorporated. Adobe Photoshop is either a registered trademark or a trademark of Adobe Systems Incorporated in the United States and/or other countries.

12  11  10  09  08      5  4  3  2  1

DISTRIBUTED IN CANADA BY FRASER DIRECT
100 Armstrong Avenue
Georgetown, ON, Canada  L7G 5S4
Tel: (905) 877-4411

DISTRIBUTED IN THE U.K. AND EUROPE BY DAVID & CHARLES
Brunel House, Newton Abbot, Devon, TQ12 4PU, England
Tel: (+44) 1626 323200, Fax: (+44) 1626 323319
Email: postmaster@davidandcharles.co.uk

DISTRIBUTED IN AUSTRALIA BY CAPRICORN LINK
P.O. Box 704, S. Windsor NSW, 2756 Australia
Tel: (02) 4577-3555

**Library of Congress Cataloging in Publication Data**
Chiang, Doug.
  Mechanika : creating the art of science fiction with Doug Chiang / Doug Chiang. -- 1st ed.
    p. cm.
  Includes index.
  ISBN-13: 978-1-60061-023-3 (pbk. : alk. paper)
  1.  Fantasy in art. 2.  Science fiction in art. 3.  Drawing--Technique. 4. Painting--Technique. I. Title.
  N8217.F28C48 2008
  700'.415--dc22                    2007044289

Edited by Mona Michael
Designed by Guy Kelly
Production coordinated by Matt Wagner

METRIC CONVERSION CHART

| To convert | to | multiply by |
|---|---|---|
| Inches | Centimeters | 2.54 |
| Centimeters | Inches | 0.4 |
| Feet | Centimeters | 30.5 |
| Centimeters | Feet | 0.03 |
| Yards | Meters | 0.9 |
| Meters | Yards | 1.1 |

## ACKNOWLEDGMENTS

My deepest appreciation to all my friends who have inspired me over the years. Special thanks to Josh Viers, David Craig, Erin Collins, Jennifer Hsyu, Mona Michael and Pamela Wissman.

## DEDICATION

For my sons, Jake and Ryan, and my daughter, Audrey, whose enthusiasm for drawing inspired me to create this book. For my wife, Liz, whose endless encouragement, support and patience guided me through its completion.

# CONTENTS

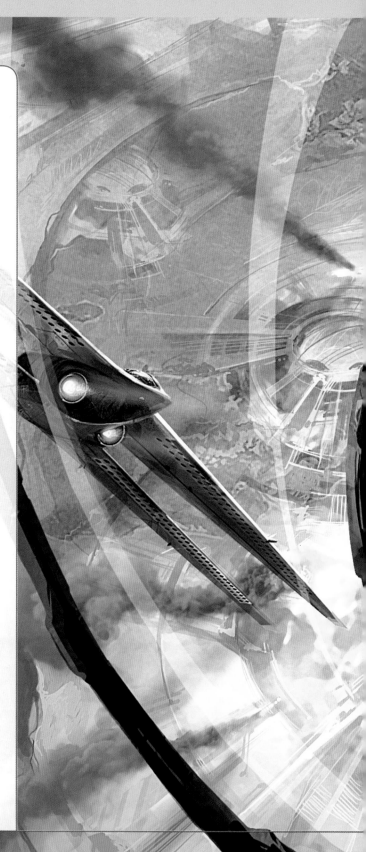

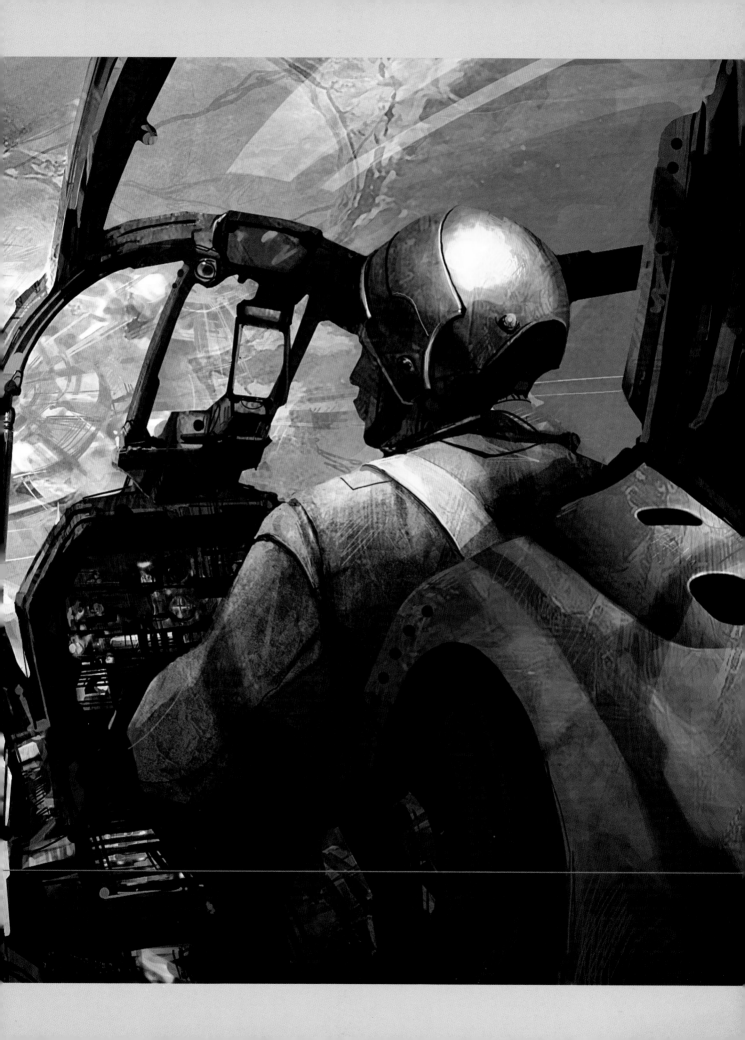

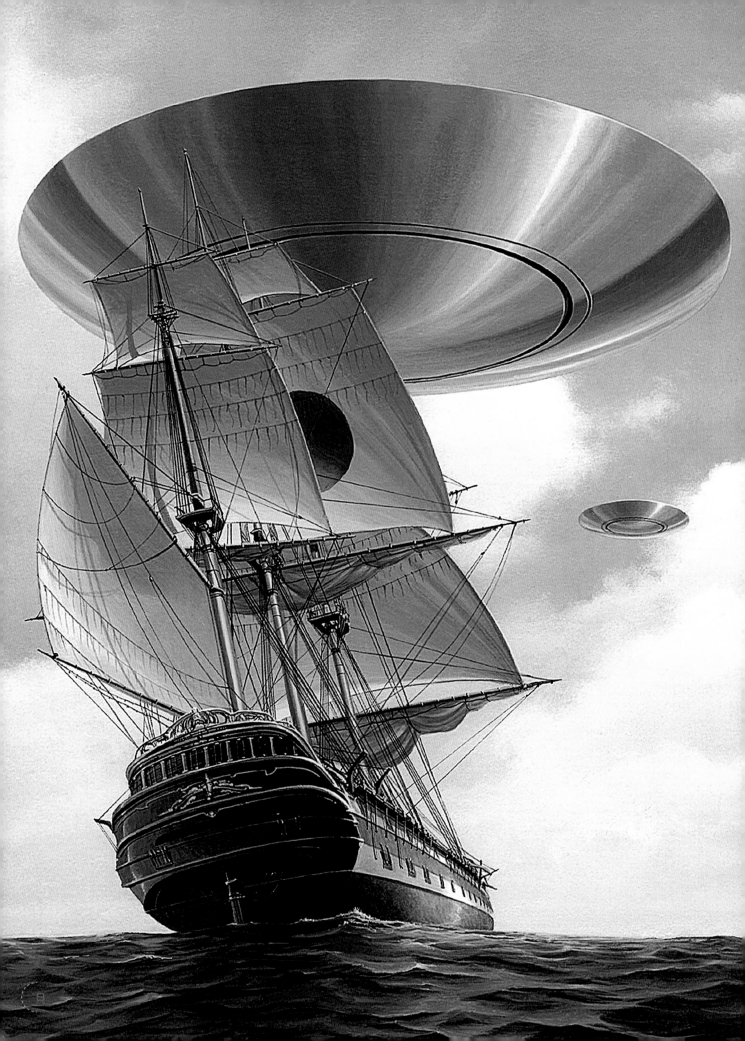

# FOREWORD BY
# ROBERT ZEMECKIS

Every artist has special techniques: unique methods for getting the job done, communicating his or her vision, and translating vague or fantastic concepts into captivating designs. It's no secret that these skills develop over time—not overnight. An artist may spend a lifetime hunched over a drafting table or squinting at a computer monitor. When techniques are shared, other artists continue the creation in new directions.

Doug possesses a rich and diverse set of drawing styles. Over the many years that we've worked together, I have had the pleasure of seeing his work grow and change. He mixes the oldest traditional methods with the newest emerging technology and makes artwork that's unlike anything we've ever seen. From his blueline pencil sketches to his fully rendered digital paintings, Doug creates a fascinating reality, no matter how imaginary the subject might be.

And although techniques are crucial for an artist, it is the ideas and concepts that define an artist. What is most important about this book is that Doug shares not only his drawing techniques, but also his thinking process.

Now that Doug has divulged some of his secrets, it will be exciting to see what comes next in their evolution.

**First Contact**
From *Robota* (Chronicle Books 2003)
Acrylic painting

# A NOTE FROM THE AUTHOR

Growing up in the suburbs in Michigan, I spent my childhood days doodling exotic creatures and giant robots. Back then, I could not have imagined that someday I would be fortunate enough to do this for a living. Today, as I watch my kids draw, I'm reminded of the innocence and creativity of the child's mind, completely unbound by rules, or reality, or logic. My kids draw imaginative, sometimes impossible, creations— not because they are deliberately breaking rules, but simply because their creations fit the logic of their world. This pure, unbridled creativity is crucial for good science fiction design.

All good ideas, though, need solid techniques in order to realize them on paper. In this book I will demonstrate a variety of techniques that have worked well for me. These techniques have evolved out of my twenty years of film designing experience; they are not the result of formal art training. I bend rules when I can and strive to be flexible in my approach. As a result, I don't have hard-and-fast rules. In fact, most of my techniques are based on gut instincts about what feels and looks right.

Use this book as a starting point to find your own style. Keep in mind that what works well for me may not work for you. Adopt what is useful and throw away what is not. In the end, always remember that techniques are just tools; the ideas are what matter most.

## THE CHALLENGE OF SCIENCE FICTION DESIGN

Speaking of ideas, it may seem as if fantastic worlds demand fantastic ideas. But often that is not the case. Viewing common objects from uncommon points of view can turn the ordinary into the extraordinary; it's a matter of training yourself to observe our world from new perspectives.

Research is the key. In order to design a future, you must look into the past. The vast wealth of information accumulated from thousands of years of human ingenuity is a great source of inspiration. The challenge is knowing how to tap into this resource.

Turn, for example, an ancient Mayan ceremonial mask into an exotic robot design, or a submarine into a levitating land vehicle, and suddenly you have created something unfamiliar and yet familiar at the same time. Think about tricks like those when using research for inspiration. The bonus when you invent in this manner is that your new creations will be automatically infused with the same rich history as the original sources of inspiration.

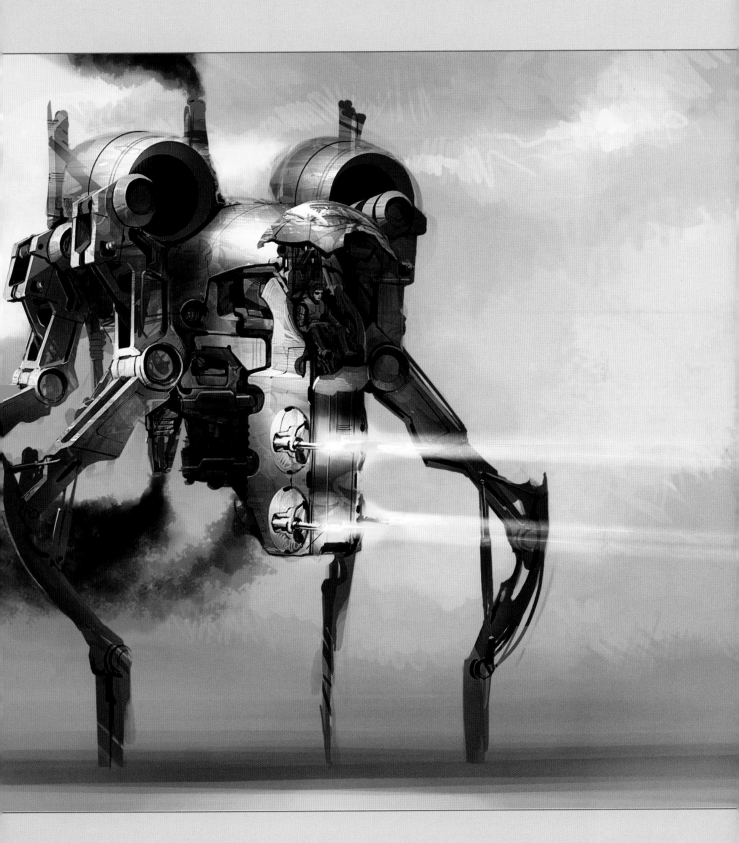

# DESIGN TOOL KIT

My complete design tool kit is shown on the facing page. I like to keep it simple. I use a small plastic triangle with an inking edge for clean lines. I find white vinyl erasers much better than other eraser types because they don't leave a residue. For highlights and corrections, I like Pro White paint, applied with a small Winsor & Newton series 7 (kolinsky sable) brush. For airbrush effects, I use a spray marker unit with air compressor (see pages 14–15 for more on markers and spray marker units). For digital work, I use a Mac with a Wacom tablet and Adobe® Photoshop® image editing software.

**Table Setup**

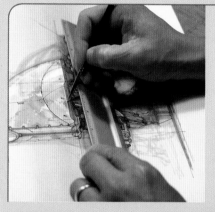

**Metal Ruler in Action**

A metal ruler is invaluable as a straightedge and can even be used as a guide for painting straight highlights.

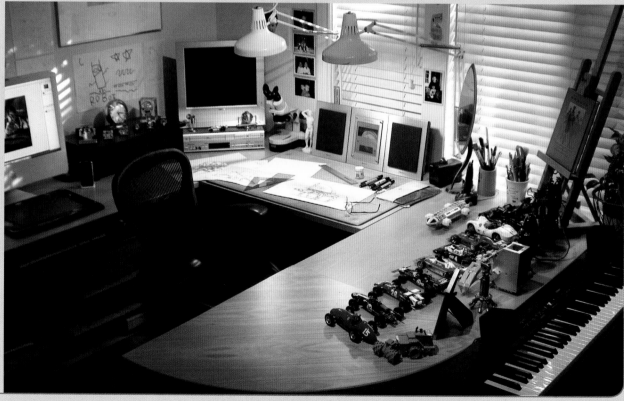

## My Studio

My studio desk layout is simple. The U-shaped configuration allows me to surround my workspace with reference material. Note the diecast model cars. I collect vintage diecast Formula-1 cars to study their mechanical components. The open wheel suspension systems of these cars are great sources for robot parts.

# TOOLS USED IN THIS BOOK

## SURFACES

Post-it note pads 3" × 3" (8cm × 8cm)

Premium white 28-lb. (105gsm) color copier paper, 11" × 17" (28cm × 43cm)

## MARKERS

Prismacolor: Black; Cool Grey 30%, 50%, 60%, 70% (see page 14 for more information about marker choices)

## OTHER

8-inch (20cm) 45°/90° plastic triangle with inking edge

12-inch (30cm) metal ruler

Air marker system

Blueline pencil

Computer with Adobe Photoshop (not pictured)

Craft knife (not pictured)

Daler-Rowney Pro White opaque watercolor paint

Fine-tip black pen

Pointed round kolinsky sable brush, 1/16" (2mm) diameter

Scissors (not pictured)

Small and large ellipse guides, sizes 10°–80°

Spray adhesive (not pictured)

White vinyl eraser

You don't have to spend a lot of money on markers and paper to get good results. Just keep a few things in mind.

## PAPER

For paper, I use premium color copier paper. Color copier paper works well with markers because it has a coating that helps keep marker from soaking into the paper fibers and causing feathery "marker bleeds." Paper brand isn't as important as the quality and finish of the stock. I prefer at least 28-lb. (105gsm) paper with a brilliance rating of 98. There are types of paper made specifically for marker sketching, but I don't find them necessary. Personal preference should determine your choice. Even though I like the feel and texture of premium color copier paper, you may find vellum or other paper products better

**Gray Markers**
Throughout these pages, you'll notice I use gray markers a *lot* for sketching. I always keep about a dozen of each gray tone in airtight bags, clearly labeled with the value percentage.

suited to your needs. Experiment with different paper weights, finishes and brands until you find one that fits your style.

## MARKERS

Experiment with different marker brands and pick whichever feels most comfortable to you. Whatever your choice, always use the broadest nib the brand offers. The broad nibs of Prismacolor markers are wonderful and allow for varying line qualities depending on the amount of pressure you apply. Tria markers are great as well and have multiple nibs for even more line control.

For airbrush effects, I sometimes use an air marker system. These systems have a tiny air nozzle on an adaptor that clips onto the marker near the nib. You connect the nozzle to an air compressor, and the compressed air blows across the nib, creating a spray of ink. It should be noted that digital airbrushing tools can replace the spray marker technique demonstrated in this book. However, if you would like to be a purist and use an air marker system, I suggest buying a brand with adaptors that fit your markers. If that is not possible, modify the system to work for you. I adapted my old Letraset spray marker system to use Prismacolor markers. Hacking into tools like this gives you the freedom to mix and match tools and brands. I encourage you to do the same so you aren't restricted either.

**Home-Adapted Air Marker Setup**
The Prismacolor markers I like don't fit in my Letraset air marker system, so I cut the marker adaptor to accommodate the thicker Prismacolors.

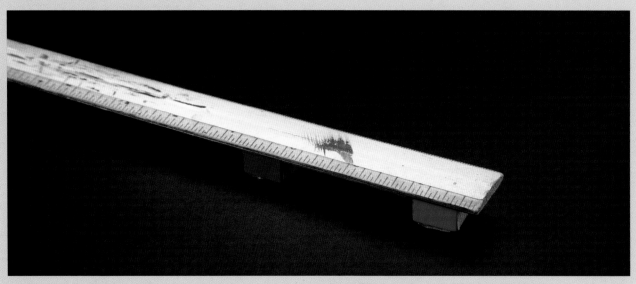

## MARKER FINISHING TECHNIQUES

Achieving smooth tonal blends is the toughest challenge of good marker technique. Besides using the right paper, the secret is speed. Since the markers are alcohol-based and dry quickly, it's important to work fast while the paper is still moist from the markers to get smooth blends between marker tones. Marking too slowly will result in hard edges and a scraggly look. This is OK if that's the effect you are striving for, but in most cases, you'll want smooth blends between tones. Try to complete the entire marker blending stage in twenty minutes or less. This means individual sections must be finished in a couple of minutes. This may sound intimidating, but practice is the key.

Work in small areas, going from the lightest marker value to the darkest. Generally, it's best to work from background to foreground, large to small areas, round to flat shapes.

Also, keep in mind that markers dry lighter in value. You may need to compensate in order to achieve the right balance of lights and darks so that the forms will read properly. If you need to rework the marker values, make sure you do it before the marker dries.

### Don't Shy Away From Art Tool Modification

If what's on the market doesn't suit your needs, alter it. For example, I still use an old wooden school ruler with glued-on Lego pieces as my artist's bridge. The Lego pieces provide just the right clearance off my board, while the ruler's metal edge gives me the perfect smooth edge for my brushes. All my Star Wars production paintings were completed using this homemade tool. It may look silly, but it gets the job done better than my store-bought bridges.

### Work Fast When Blending With Markers

Complete marker blends in twenty minutes or less to avoid harsh, rough edges.

# SKETCHING BASICS

The design process always begins with a sketch. Knowing how to effectively sketch gives you the necessary skills to begin to conceptualize ideas. Here are two sketching techniques that have worked well for me over the years.

## MARKER SKETCHES

Marker sketching is my favorite drawing technique. I have discovered that Cool Grey 30% markers are ideally suited for this. The Cool Grey color is neutral, and the 30% value is dark enough to see, yet light enough not to overpower the final pen work.

Using a broad nib forces you to focus on the overall shape instead of the details. Be bold, and don't be afraid of mistakes. Allow the marker to bleed into the paper to make new shapes and create happy accidents. These mistakes will give life to the drawing later.

## POST-IT NOTE SKETCHES

Sketching with blue pencils on Post-it notes is a great technique to use if you don't have strong initial ideas. The small size of the Post-it note forces you to think in terms of major shapes and not details. With this method, there is little pressure to produce good drawings, so you can focus on generating lots of ideas. (I use Sanford Col-erase number 20068 Light Blue pencil on 3" × 3" [8cm × 8cm] Post-it notes. Nonphoto blue pencils work also, but I find them too light in value.)

The only catch with this technique is that you will need to re-draw the final design at a larger size on a separate piece of paper. By contrast, in marker sketching, the rough sketch becomes your final sketch.

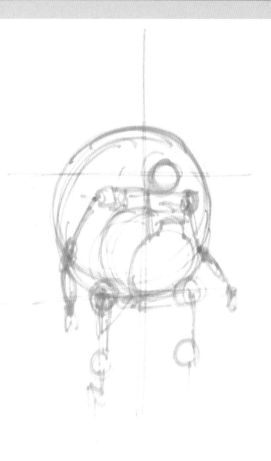

**Marker Sketches**
Before you start sketching using markers, you should have some idea of what you want the finished piece to look like. Many of the key elements of the Comm Robot design (page 38) were already in place in this beginning sketch.

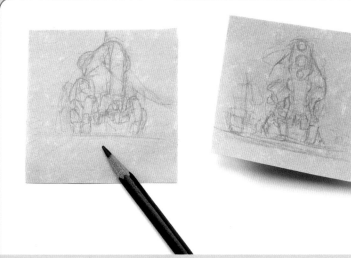

**Post-it Note Sketches**
Ideas sometimes come easier with low-pressure sketches like these.

# FOUNDATION LINES

I use three types of foundation lines to help give structure to drawings:

- Perspective lines
- Construction lines
- Action lines

All three types establish the spatial relationships of the drawing and serve as guidelines for the final design. Construction and action lines are more subjective and are not required for all drawings but can strengthen a design if used properly.

All three line types, when used together, determine the three-dimensional quality of the drawing. Typically, I place perspective lines first. After some initial sketching, I put in construction and action lines. I always keep these lines in the finished drawing since they add energy to the artwork.

## PERSPECTIVE LINES
Perspective lines are objective lines that are perhaps better known than the other two line types. Although perspective lines are very important and an integral part of the drawing, I don't apply them rigidly. In fact, I rarely lay down perspective lines with geometric precision. You'll notice that many of my perspective lines are mere approximations. This is common in freehand sketching, and I do this for speed as well as to keep the drawing organic and alive. As long as the drawing appears to be in proper perspective, that's all that matters.

However, a firm understanding of two- and three-point perspective is essential. There are a lot of good books avail-

able to help you learn the basics. Ask your local art supplier, bookseller or librarian for recommendations.

## CONSTRUCTION LINES
Construction lines help control and delineate structure and form. They are similar to perspective lines, but their application is a bit more abstract. Think of them as guides to contain shapes or to tie two parts of the drawing together. They don't necessarily follow perspective lines but can replace them in some cases. For example, they can be used to ensure that two engine parts line up properly. Or they can line up a series of shapes, or define the axis of an ellipse.

## ACTION LINES
The term *action line* comes from the comic book world. These lines establish the main thrust of action or movement or the main axis of a form. I use them primarily to help compose drawings and to ensure that a design has dynamic composition and form.

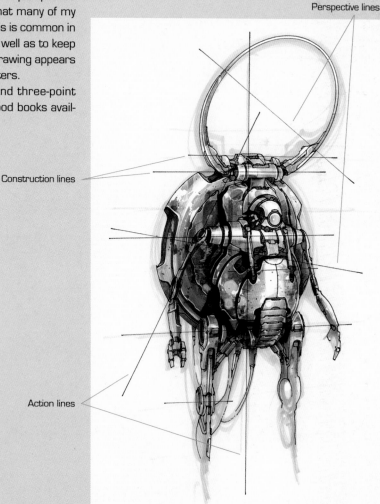

Perspective lines

Construction lines

Action lines

# ABOUT DIGITAL PAINTING

Image editing software such as Adobe Photoshop has transformed design and painting. Even though Photoshop isn't really considered a paint program, it is nonetheless great for painting. The software mimics traditional techniques very well and offers a wide range of powerful tools that dramatically streamline and simplify the painting process. Furthermore, the software has special layering, filtering and lighting effects that are impossible to achieve traditionally.

But perhaps Photoshop's greatest advantage is its speed and ease of use. Traditional acrylic paintings that previously took me four days to complete can be done digitally in less than a third of that time.

If you haven't painted digitally before, the software can be overwhelming. As with any other set of art tools, use only what is useful to you. Keep it simple; there is no need to learn the full program. I use only a small portion of it myself. For example, I use only two brush types: hard rounds and soft rounds. I set the brush size to vary according to pen pressure, which lets me use my graphics tablet to mimic real brushes. There are numerous other brush settings and shapes, but I don't find them necessary.

Besides the Brush tool, the other Photoshop tools I use most often are:

- The Eraser tool in Brush mode, using hard and soft brush shapes
- The Dodge and Burn tools, with hard and soft brush shapes (*Dodge* and *burn* are traditional darkroom terms meaning lighten and darken.)
- Selections and masks
- The brush in Color Dodge mode (great for painting quick and easy glowing effects)
- The Soft Light layer option
- Cloning brush

## DESIGN TIP

Make sure you create your digital paintings large enough. I like to paint at around 7" × 10" (18cm × 25cm) at 300 ppi, the resolution needed for most color printing. The larger you create your paintings, the more flexibility you have for using them in print projects. The limit depends on the speed of your computer and how much RAM and disk space it has.

**My Photoshop Brush Palette**
The Shape Dynamics brush option in Photoshop is where you can set the brush size to vary with pen pressure. Photoshop offers many brush shapes, but hard and soft rounds are all I ever need.

# THE KEYS TO GOOD DESIGNS

Since design can be subjective, it is hard to know whether a design is strong and successful. Over the years I have come up with some simple tests to help me determine this. Keep in mind these aren't strict rules; they're merely guidelines. There will be exceptions.

## 1 A STRONG SILHOUETTE

Design for iconic shapes. Always think in terms of strong silhouettes before focusing on the fine details. Squinting your eyes occasionally will help you concentrate on this. Remember, details embellish the overall design but don't determine it.

## 2 THE THREE-SECOND RULE

With iconic shapes in mind, create designs that can be understood in three seconds or less. The three-second rule evolved out of my film experience. Often audiences have less than three seconds to understand what they are viewing before the shot changes, so it is essential to keep the design clear. For example, if it's a vehicle, the viewer must be able to determine quickly where the pilot sits, in which direction the vehicle is going, its purpose, etc. These things may sound simple, but they are often neglected. Always strive to keep the overall form easy to understand.

## 3 PERSONALITY

Ask yourself: Is the design powerful? Weak? Menacing? Are those traits reflected in the design? When personality is infused into your designs, the end result is more effective.

## 4 FUNCTIONALITY

Would the design work? You must have an idea how your design would function. Confirm functionality before moving on to the next question.

## 5 BELIEVABILITY

Is it plausible? Does it look as if it can perform the function that you designed it to? This is the believability test. This doesn't mean that every joint and hinge needs to be figured out in great detail, but a basic appearance of practical function is essential.

## 6 COOL FACTOR

This one is very subjective and a bonus if it can be achieved. This is the emotional difference between a sports car and a commuter car. Both vehicles are made for transport and both have the same basic configuration, but one addresses its purpose with much greater flair. Do the same in your designs.

---

## DESIGN
### QUICK TEST

Here is my checklist for good designs. Ask yourself each of these questions to evaluate your own work.

**1 Strong Silhouette:** Is your design iconic?

**2 Three-Second Rule:** Can you easily understand the design in three seconds or less?

**3 Personality:** Does the design have personality such as benign, powerful or weak?

**4 Functionality:** Can you easily tell how it works and what it's supposed to do?

**5 Believability:** Is the design mechanically plausible? Does it look as if it can work?

**6 Cool Factor:** Is the design unique and interesting to look at?

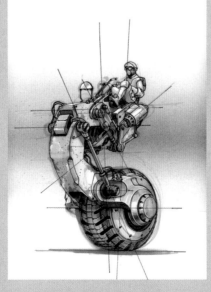

**Design Test Results**

The Monopod (page 22) is a good test of this checklist. It has a strong, unique silhouette. The single wheel quickly determines its function and purpose and satisfies the three-second rule. The vehicle's unusual shape gives it personality, while the simple aesthetics of construction equipment anchors it in our world and makes it believable. Last, it looks cool and fun to drive. It has strong emotional appeal because gyroscopically stabilized transport vehicles are not commonplace.

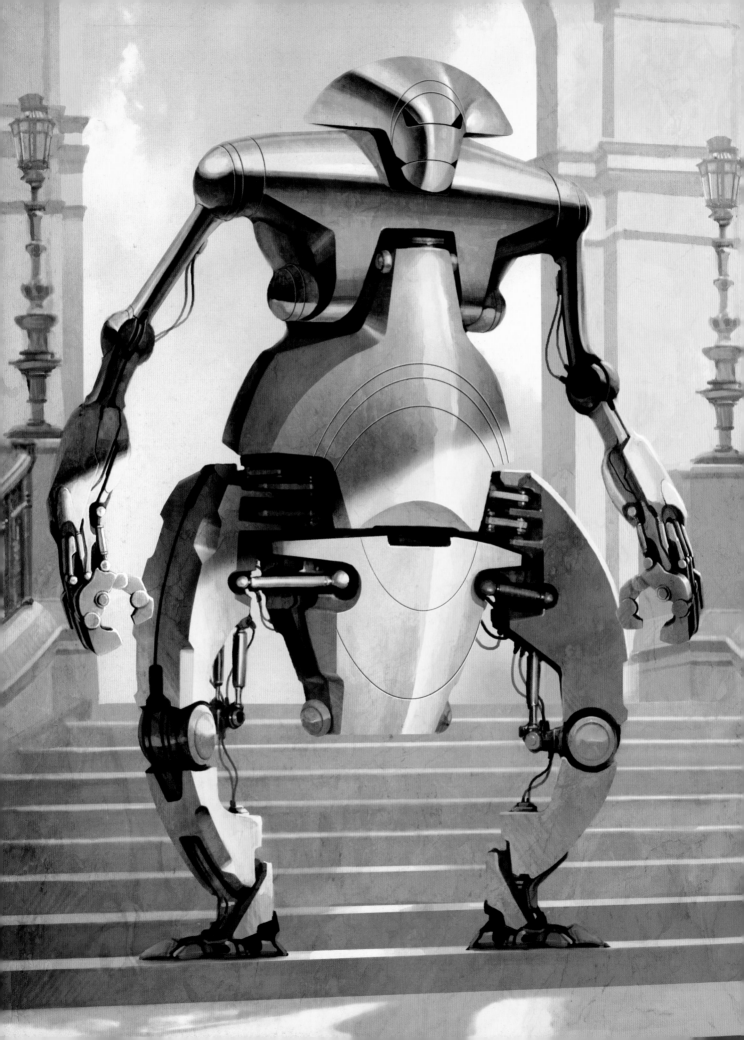

# ROBOTS AND MACHINES

# monopod

Small, single-person transport vehicles are staples of science fiction. For this demo, I add a twist to the concept by distilling the design down to its most basic functional elements: a wheel and a seat.

Stylistically, I want to ground the concept in the aesthetics of heavy construction equipment. This will anchor the design in reality. The odd component will be the single, gyroscopically stabilized wheel.

**SURFACE**

Post-it note pad, 3" × 3" (8cm × 8cm)

Premium white 28-lb. (105gsm) color copier paper, 11" × 17" (28cm × 43cm)

**MARKERS**

Cool Grey 30%, 50%, 60%, 70%

**OTHER**

8-inch (20cm) 45°/90° plastic triangle with inking edge

12-inch (30cm) metal ruler

Air marker system

Blueline pencil

Daler-Rowney Pro White opaque watercolor paint

Fine-tip black pen

Pointed round kolinsky sable brush, 1/16" (2mm) diameter

Scissors

Small and large ellipse guides, sizes 10°–80°

Spray adhesive

White vinyl eraser

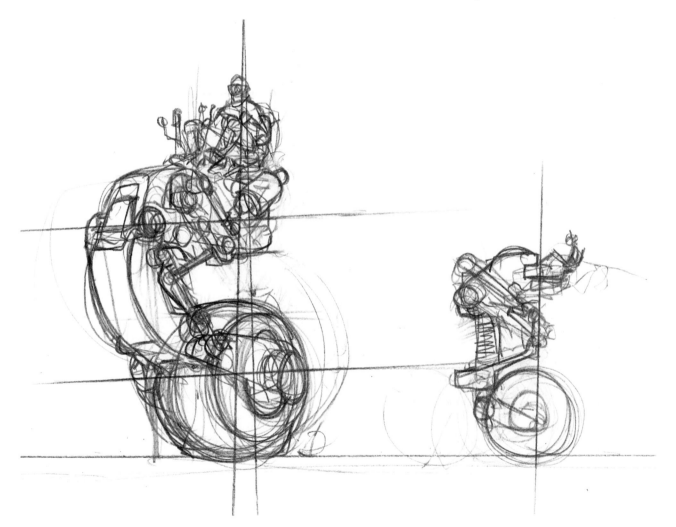

**STAGE 1** Blueline Thumbnail Sketches

Create small, rough blueline sketches on Post-it notes. Plan on throwing away these drawings so don't spend too much time on them. Remember that blueline pencil sketches are about generating ideas, not about making pretty pictures.

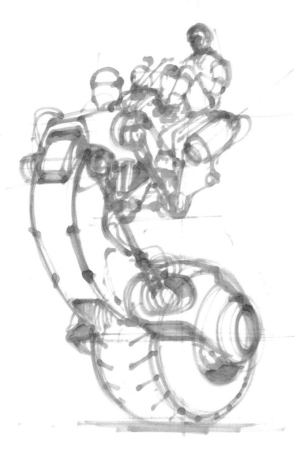

**STAGE 2** Marker Sketching

Using the Cool Grey 30% marker, redraw your favorite design at the final size on color copier paper. Here, the sketch is about 8" × 10" (20cm × 25cm). Remember to use the broad nib of the marker and to focus on shapes, not details.

**STAGE 3** Construction Lines and Preliminary Inking

Using the triangle, ellipse guides and fine-tip black pen, draw the main construction lines and small ellipses first. The smaller ellipses will guide the remaining larger ellipses. Putting down the perspective lines with ink keeps them anchored as you continue to refine the drawing.

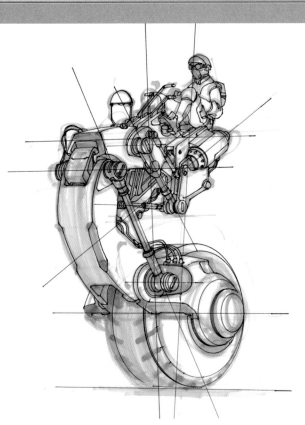

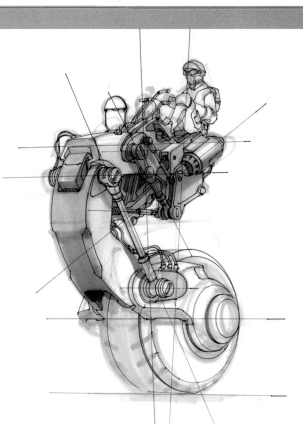

## STAGE 4 Defining Details

Here's where the happy accidents from the previous marker stage become important. Notice that the gray marker lines have bled into the paper, creating interesting positive and negative shapes. Squint your eyes at these shapes and look for mechanical forms. It'll take some practice, but you'll start to see shapes that couldn't be planned. Turn these unplanned shapes into mechanical parts using your fine-tip black pen. To keep the drawing interesting, don't define everything. During this stage, it can be helpful to add some preliminary shading to clarify the form. Here, I've added some tone to the underside of the vehicle to define its shape.

## STAGE 5 Tone Markers

With your line work done, use the Cool Grey 30%, 50%, 60% and 70% markers to give volume and form to the vehicle. The markers dry quickly, so work in small areas, going from the lightest marker to the darkest, making sure the area remains wet so the darker tones will blend with an even gradation into the lighter tones. Work from back to front, large areas to small.

## STAGE 6 Finished Markers

Complete this stage in twenty minutes or less—any longer, and the markers will have dried completely, and re-markering will create hard edges instead of smooth gradations. Also remember that markers lighten as they dry, so you may need to rework certain areas to achieve the right balance of light and dark. Reworking is okay if done within the twenty-minute window.

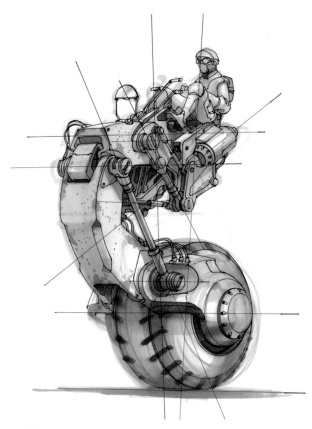

## POSITIVE AND NEGATIVE SHAPES

Use positive and negative shapes to clarify the design. Positive shapes are the ones you draw, while negative shapes are the remaining areas that surround the drawn shapes. Interestingly, it's often the negative shapes that determine the effectiveness of a design because they create the silhouette. And from our design checklist (page 19), you know that a strong silhouette is key to a strong design. Train yourself to be aware of these negative shapes as you draw. Positive and negative shapes are equally important and work hand in hand to create solid designs.

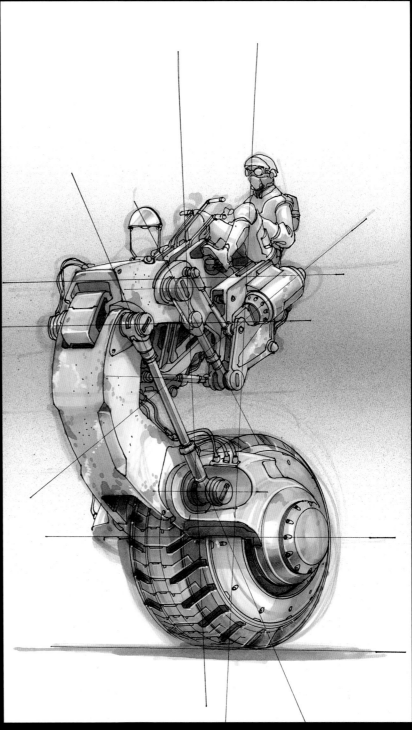

**STAGE 7** Highlights and Final Details

Add highlights and corrosion effects with Pro White using the small round brush. Use a metal ruler to paint straight highlights (see page 12). Notice that I've added more details to the tire while leaving portions of the vehicle unfinished. This contrasts detailed areas with unfinished areas and makes the drawing more interesting.

For the background, use the spray marker with the Cool Grey 70% marker to "airbrush" a gradation to unify the design and create a clean silhouette. Protect the areas that you don't want sprayed by photocopying the drawing at one hundred percent. Then, carefully cut out the copy and apply a small amount of spray adhesive to the backside. Lightly tack this copy to your sketch to create a mask for your air marker.

# r-robot

Often when I approach figure drawing, I start by breaking down the human form into basic mechanical components, drawing the mechanical skeletal structure first. This helps me understand the human form and it's an easy step from there to transform that mechanical breakdown into an interesting robot design. In the case of humanoid robots, joints are the key.

## SURFACE
Premium white 28-lb. (105gsm) color copier paper, 8½" × 11" (28cm × 43cm)

## MARKERS
Cool Grey 30%, 50%, 60%, 70%

## OTHER
8-inch (20cm) 45°/90° plastic triangle with inking edge
12-inch (30cm) metal ruler
Daler-Rowney Pro White opaque watercolor paint
Fine-tip black pen
Pointed round kolinsky sable brush, 1/16" (2mm)
Small and large ellipse guides, sizes 10°–80°

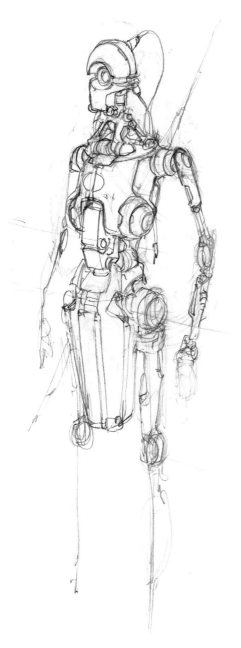

## STAGE 1 Blueline Sketching

Starting with a blueline pencil and working at the final size, sketch the pose and construction lines, choosing a relaxed, natural stance. Next, thinking about joints and using the black pen, consider functionality and movement and the types of mechanical joints necessary for that. The torso is a key focus area because of its complex multiple rotation axis, so begin there. In this case I chose universal U joints as the foundation. They have interesting designs and help define the aesthetics of the robot.

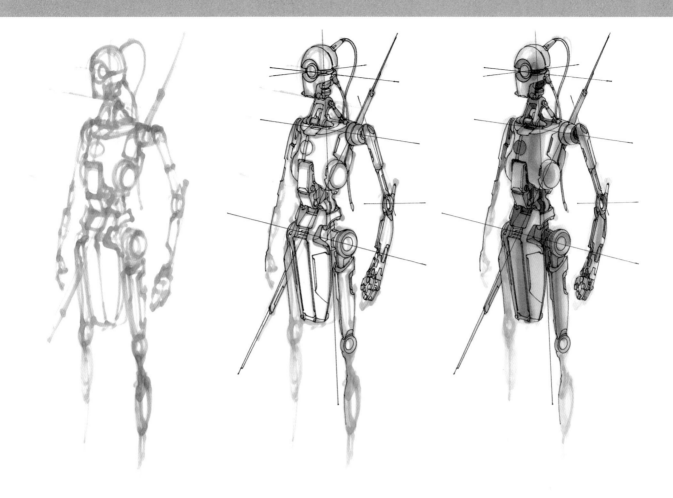

**STAGE 2** Marker Sketching

Using the Cool Grey 30% marker, quickly redraw the design. The reason for this step is to simplify the original blueline sketch to ensure design clarity. Quickly redrawing with a broader-tipped tool helps you spot and correct proportion mistakes and focus on design clarity—things that you might have overlooked in the blueline sketch.

**STAGE 3** Construction Lines and Detail Work

Using the triangle and ellipse guides, anchor the perspective for the drawing. Line up the small axis of ellipse guides to point to the vanishing point of the drawing. Sometimes it's helpful to actually define the small axis with a line as I have done here. With the perspective defined, ink the final design details, refining what you sketched in Stage 1. Again, notice that I deliberately leave parts of the drawing unfinished to keep it interesting.

**STAGE 4** Tone Markers

Establish the direction of the light source, then use the markers to give mass and form to the drawing. Work from back to front, light to dark, using Cool Grey 30%, 50%, 60% and 70%. Keep in mind the overall shape and don't worry about defining every part with these markers. It's better to keep it simple and focus only on the main shapes.

DESIGN TIP

Leaving some areas undone adds life to your design. Unless you are creating a detailed blueprint sketch, it's always best to leave some areas unfinished. For example, if you have four identical legs, don't define all four; it's enough to define two or three and suggest the rest. The unfinished portions will engage the viewer in filling in the blanks while keeping the drawing alive and loose— qualities that are essential for good design presentation.

## STAGE 5 Highlights and Reflections

Finish by adding highlights and reflections using the Pro White and the small brush, keeping in mind the light direction. Similarly, add highlights as necessary to define spherical shapes.

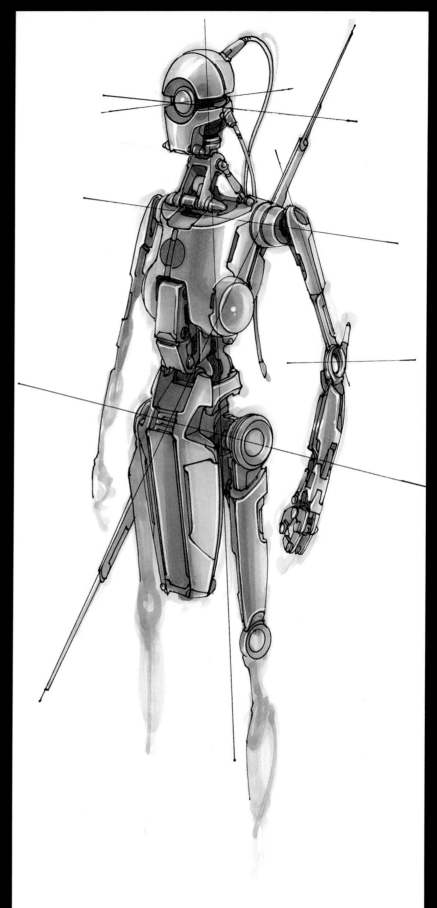

# single-person fighter cockpit

Spaceship cockpits are complex spaces and function is key to making these interiors believable. Since they are built around a person, any errors in ergonomics can spell disaster for the design.

## SURFACE

Premium white 28-lb. (105gsm) color copier paper, 11" × 17" (28cm × 43cm)

## MARKERS

Cool Grey 30%, 50%, 60%, 70%

## OTHER

8-inch (20cm) 45˚/90˚ plastic triangle with inking edge
12-inch (30cm) metal ruler
Air marker system
Blueline pencil
Daler-Rowney Pro White opaque watercolor paint
Fine-tip black pen
Pointed round kolinsky sable brush, 1/16" (2mm)
Small and large ellipse guides, sizes 10˚–80˚
White vinyl eraser

 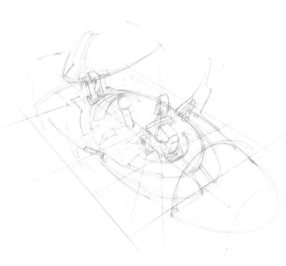

**STAGE 1** Establish Perspective Lines

With the blue pencil and the triangle, draw a grid to determine the ground plane and establish a "floor." Then add vertical lines to serve as guides for the "walls." Even though the cockpit won't have a floor or a wall, these perspective lines create a structure around which to build the design. This step is very important for interior spaces.

**STAGE 2** Preliminary Blueline Sketch

Sketching freehand, start blocking out the design. Keep this drawing loose, and expect to make lots of mistakes.

DESIGN TIP
Rough in the perspective lines during your blueline sketch phase. Check their precision and placement using a triangle before you begin adding ink.

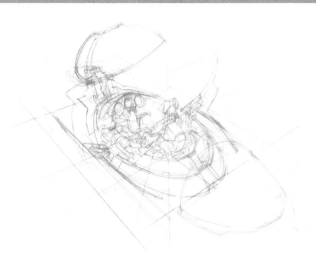

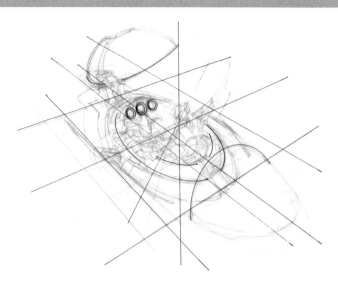

**STAGE 3** Further Refinements

Keep working with the blue pencils until the details begin to emerge and define themselves. At this stage, the drawing is rather confusing to look at.

**STAGE 4** Perspective Lines Re-established

Now that the design is roughed in, double-check the key perspective lines and ellipses using the triangle and ellipse guides, and then ink them to help guide the detail work in the next step.

**STAGE 5** Details

Begin detailing the cockpit, the most complex part of the drawing. The four-part canopy is the unique aspect of this design. Make sure it looks as if it can fit together.

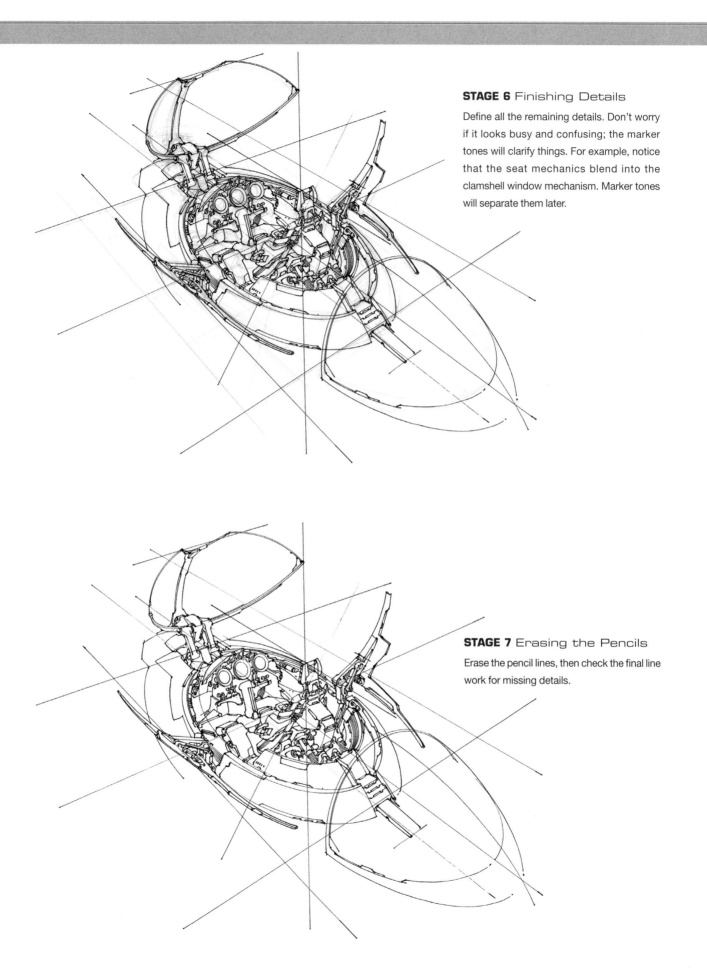

**STAGE 6** Finishing Details

Define all the remaining details. Don't worry
if it looks busy and confusing; the marker
tones will clarify things. For example, notice
that the seat mechanics blend into the
clamshell window mechanism. Marker tones
will separate them later.

**STAGE 7** Erasing the Pencils

Erase the pencil lines, then check the final line
work for missing details.

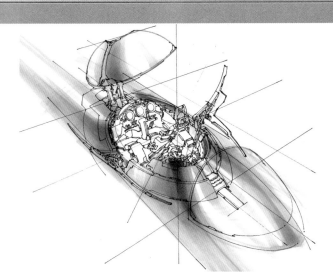

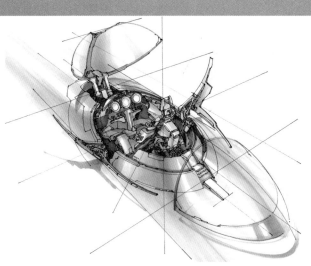

**STAGE 8** Beginning Tone Markers

Add tone to the largest shapes first. Don't worry if these tones overflow into the detail areas of the drawing; these overflows will be covered up later.

**STAGE 9** Final Tone Markers

Working from broad areas to small, do the finest details last. This allows you to cover up marker bleeds and overflows.

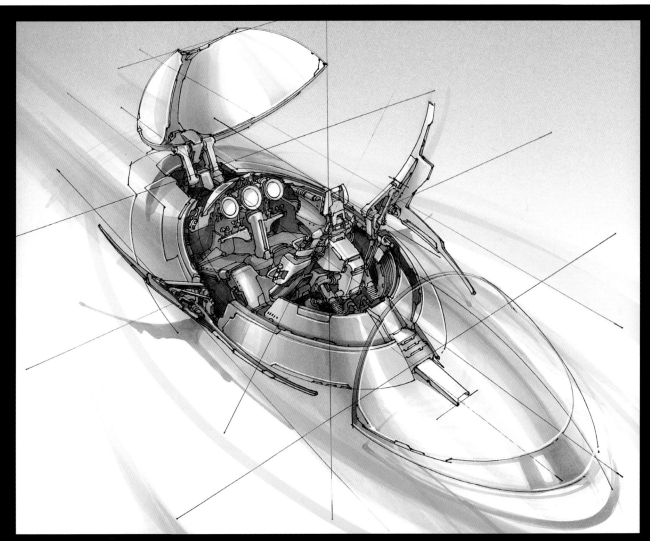

**STAGE 10** Highlights and Background

Use Pro White to punch up highlights and clean up marker bleeds. Because there are so many small details in this drawing, be careful to not overdo the highlights, or the drawing will get too busy and confus-ing. Just as you did on page 25, use the air marker system with the Cool Grey 70% marker to "airbrush" a gradation for the background. Don't forget to mask the areas that you don't want airbrushed.

# robot pilot

I'm enamored with complex, polymorphic shapes. Interior design for vehicle cockpits is fun for that reason. In this demo, you'll learn to use complex shapes to tackle the ubiquitous giant robot with a cockpit and a human pilot.

## SURFACE

Post-it note pad, 3" × 3" (8cm × 8cm)
Premium white 28-lb. (105gsm) color copier paper, 11" × 17" (28cm × 43cm)

## MARKERS

Cool Grey 30%, 50%, 60%, 70%

## OTHER

8-inch (20cm) 45°/90° plastic triangle with inking edge
12-inch (30cm) metal ruler
Air marker system
Blueline pencil
Craft knife
Daler-Rowney Pro White opaque watercolor paint
Fine-tip black pen
Pointed round kolinsky sable brush, 1/16" (2mm)
Small and large ellipse guides, sizes 10°–80°
Spray adhesive
White vinyl eraser

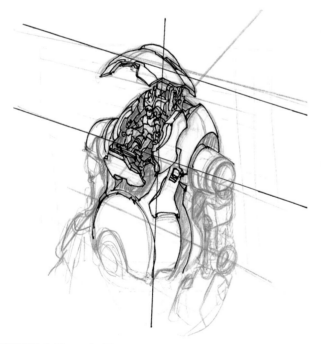

**STAGE 1** Rough Preliminary Sketch

Sketching on Post-it notes with the blue pencil, work up a rough design. After doodling with the pencil, refine the sketches with pen to pull out details and simplify the forms. For complex designs, it's good to do some preliminary inking to make sure the foundation of the design is there.

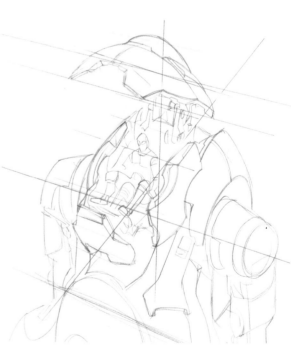

**STAGE 2** Blueline Sketch

Enlarge the sketch on a photocopier to the size you want it. Then trace the design at its final working size. Mine is about 8" × 8" (20cm × 20cm).

## STAGE 3 Detailed Blueline Sketch

Once you've blocked in the overall shape, dive in and figure out the detailed mechanics of the cockpit. This design is all about the hinges for the four-piece clamshell doors. The design of the cockpit will fall apart if the hinge mechanism isn't convincing. I used kitchen cabinet hinges for reference.

## STAGE 4 Defining Details

Begin defining details with pen, starting at the center of focus, the pilot. Define his details and work outward. Use the ellipse guides to draw the shoulder ellipses.

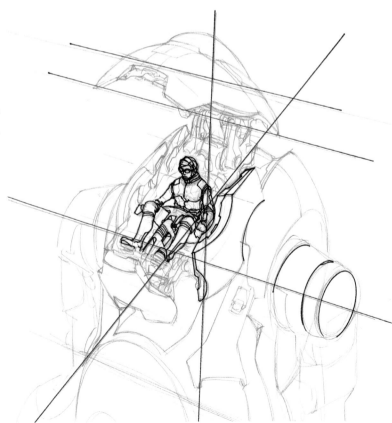

**STAGE 5** Finished Details

This step can make or break the design. Working over the blueline pencils, clearly delineate the hinge mechanisms with pen. Use photo references of real hinges and joints to help you. Keep in mind, though, that it only has to *look* like it works, so don't become obsessed with accuracy.

**STAGE 6** Tone Markers

Using the Cool Grey 30%, 50%, 60% and 70% markers, add tones to the main shapes. Work fast and in one area at a time.

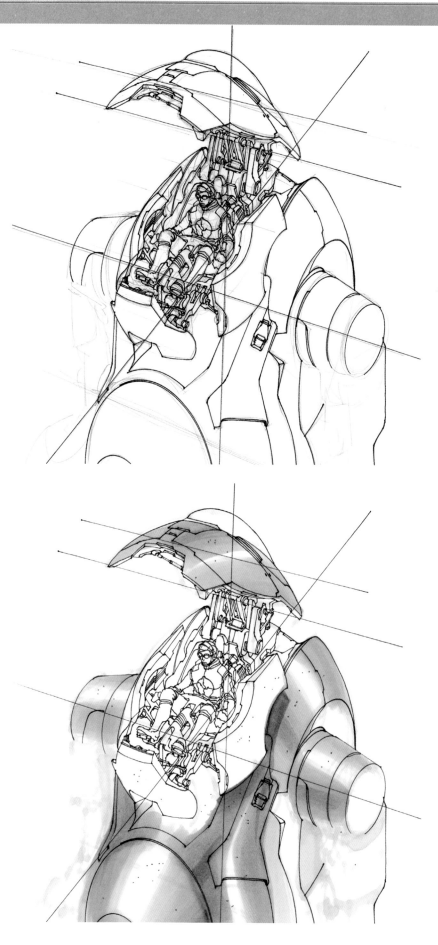

**STAGE 7** Tone Marker Finish

Tone the pilot area last, since this is the most complex part of the drawing and potentially the most confusing. Use the dark markers for clarity. Dark tone creates shadows that pull and push shapes to determine spatial placement. For detailed areas such as the cockpit, the addition of simple shadow tones immediately makes the drawing easier to understand.

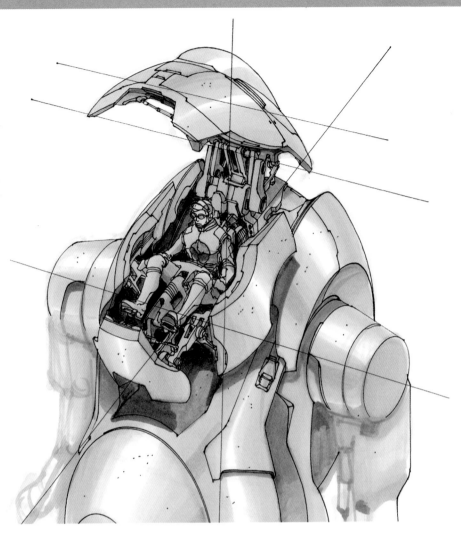

## PATCHING IN NEW ELEMENTS

Here's an easy way to correct your design without damaging it.

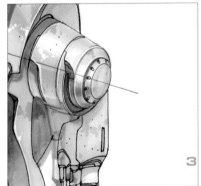

Draw the corrected area on a separate piece of paper and cut it out with a craft knife. Apply spray adhesive to the backside of the patch and paste it onto the artwork.

Trim the edges of the patch if necessary to make a seamless fit.

Using a fine-tip pen, add more line work to blend the patch into the artwork.

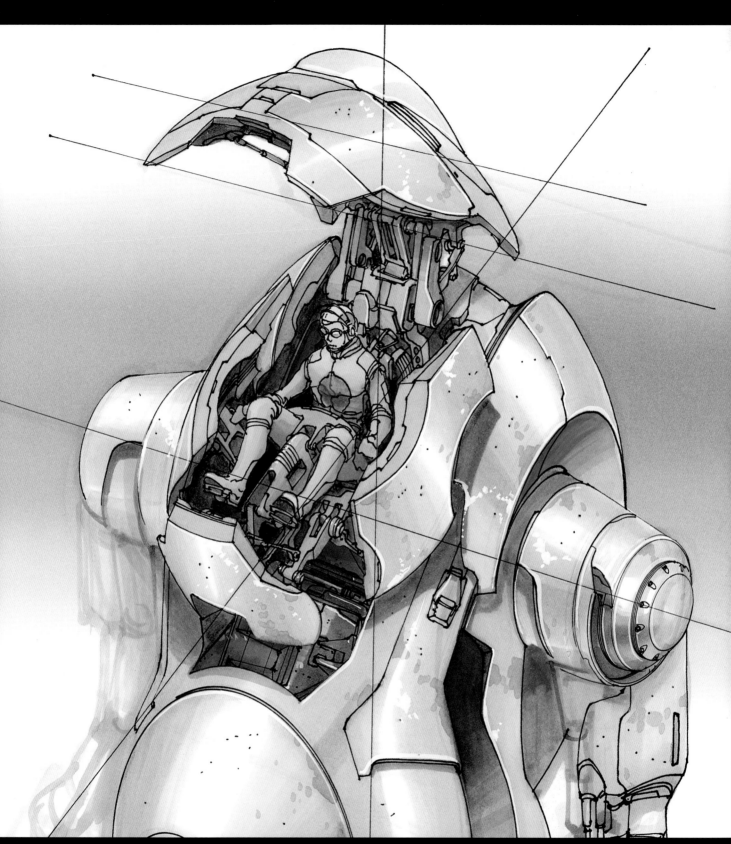

## STAGE 8 Highlights and Finishing Retouch

Use Pro White to add highlights, clean up marker bleeds and define edges. After I did this, I
noticed that my design needed more details in the shoulder and chest areas of the robot. Since
it was too late to go back and re-marker, I decided to draw *new elements* on a separate piece
of paper, then cut and paste them into the drawing. (See page 36, and compare Stages 7 and
8 to see the additions.) This is a good technique for making corrections or minor additions.

Use the air marker system to do the background, the same way you did on page 25.

# comm robot

Giving your design personality as well as functionality elevates your art to something more than just an exercise in creating forms. This is one of the keys to good mechanical designs (see page 19). Begin by determining the character traits you would like to imbue into the design. In this case, I wanted to create a communications robot that was friendly, functional, and a dependable worker. The turtle became my inspiration.

**SURFACE**
Premium white 28-lb. (105gsm) color copier paper, 11" × 17" (28cm × 43cm)

**MARKERS**
Cool Grey 30%, 50%, 60%, 70%

**OTHER**
8-inch (20cm) 45°/90° plastic triangle with inking edge
12-inch (30cm) metal ruler
Computer with Adobe Photoshop
Daler-Rowney Pro White opaque watercolor paint
Fine-tip black pen
Pointed round kolinsky sable brush, 1/16" (2mm) diameter
Small and large ellipse guides, sizes 10°– 80°

**STAGE 1** Free-Form Marker Sketching

Using the Cool Grey 30% marker, quickly establish the main construction lines and basic shapes, keeping the forms round and soft. The large ball on the robot's back reflects the turtle-shell influence. (See page 46 for more on free-form designing.)

**STAGE 2** Further Shape Refinements

Continuing with Cool Grey 30%, keep working the drawing until interesting minor shapes emerge. Although the robot is coming together, it's not clear that this is a communications robot. To address this, add a large satellite ring to its back. This gives the robot a distinct silhouette (one of the design keys on page 19) and results in a much stronger design.

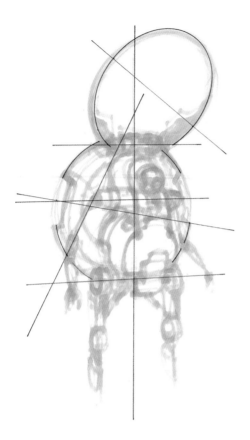

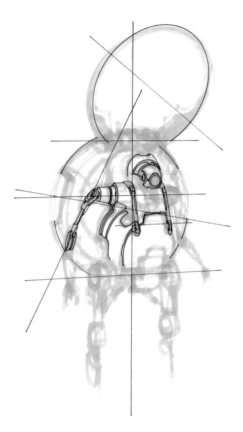

**STAGE 3** Foundation Lines

Use the pen and ellipse guides to ink the large round shapes. With the triangle, stroke in perspective and action lines. For example, the diagonal action line through the upper arm shows that the arm is being raised up and back, away from the vertical orientation of the legs.

**STAGE 4** Defining Details

Beginning with the large ellipses and the main area of focus, the head, start inking to pull out mechanical shapes. I've drawn in straps that resemble suspenders or overalls, playing on the stereotype of the overalls-clad factory worker.

DESIGN TIP

I use a triangle instead of a ruler to create foundation lines because the shape of the triangle is easier to grip and maneuver around the paper. The inking edge prevents the pen lines from bleeding and smearing.

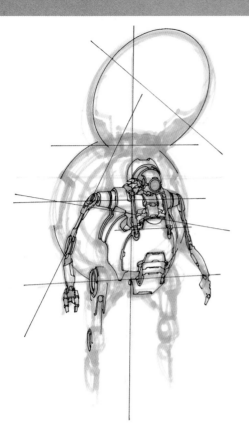

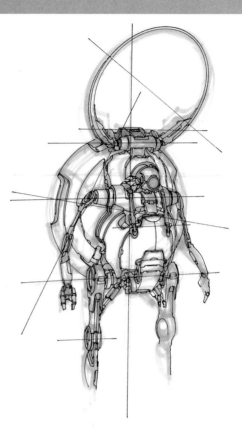

## STAGE 5 Refining Details

Continue with the pen, moving around the drawing to avoid stalling in one area. Don't worry if you can't see all the shapes right away. Sometimes coming back later to an arm or a leg allows you to see forms that weren't evident earlier.

## STAGE 6 Finishing the Linework

Look over the whole drawing as you near completion to make sure the line work and forms are balanced. Complement your shapes, juxtaposing large areas with smaller detailed areas. When you reach the right amount of detail, the large shapes and details will be in balance, and the drawing will look unified.

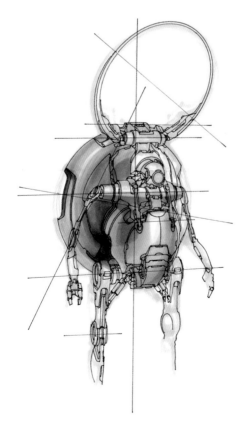

## STAGE 7 Tone Markers

Define the direction of the light source, then block in the main tones, starting with the large turtle-shaped back and moving forward.

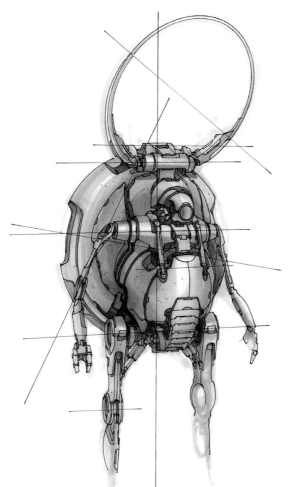

**STAGE 8** Finished Tone Markers

Squint your eyes to check how well the tones are reading. Rework areas as necessary for clarity. Reapplying the markers is OK if the markers haven't dried completely; start and finish the markers within twenty minutes.

**STAGE 9** Adding Highlights

Apply Pro White highlights with the brush. Avoid overworking the drawing; keep the highlights to a minimum. Notice that I've added cables below and behind the robot to complement the satellite ring. This visually balances the form.

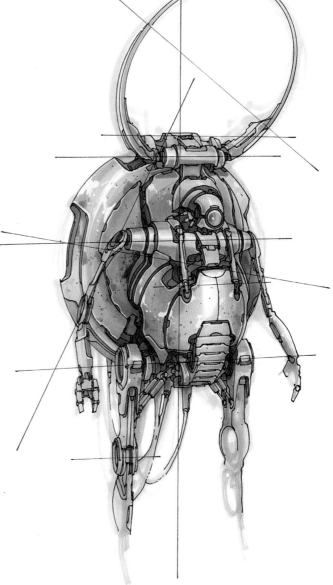

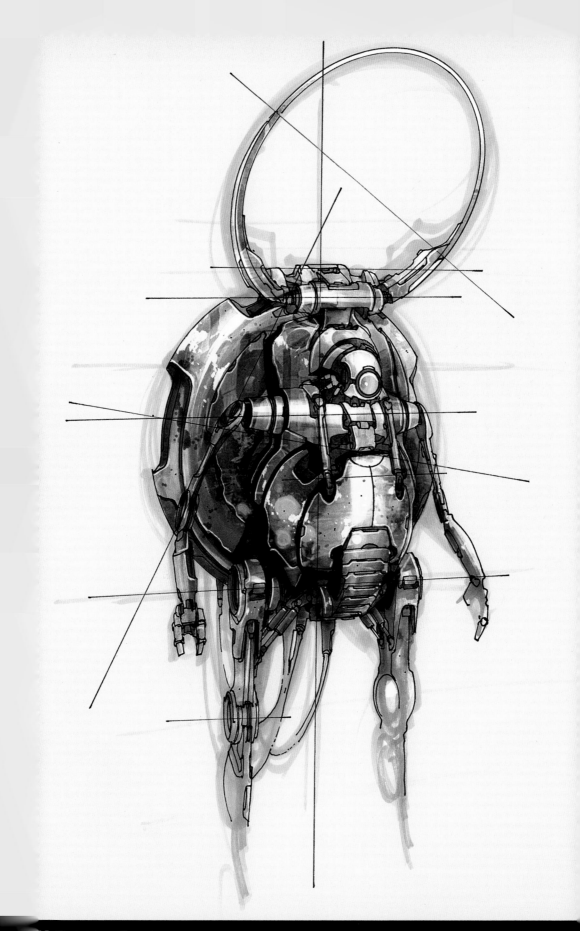

## 10 Finishing Touches

design into the computer and open it in Photoshop. Unify the
by *adding a color tint*, here a green-gray, to the entire image
ground. Adjust the opacity to about 40%. Add abstract color

patterns and textures to the robot on a *new layer*, then mix th
into the drawing by changing the layer to *Soft Light mode*. Th
*Brush tool in Color Dodge mode*, enhance the belly highlight

## PHOTOSHOP FUNCTIONS

### ADD A COLOR TINT:

Sometimes it is helpful to unify the drawing by applying a transparent color glaze to the overall image.

**1** Adjust the brightness level of the drawing by darkening the white levels (see *Level Adjustment* below). Move the slider to adjust the white level to a medium gray.

**2** *Create a new layer* and fill this layer with the desired color to tint the image.

**3** In the Layer attributes, change the layer to Vivid Light and adjust the opacity to achieve the desired color tint.

### LEVEL ADJUSTMENT:

From the Image menu, choose Adjustments, then Levels. Move the sliders to increase or decrease the contrast and brightness.

### CREATE A NEW LAYER:

From the Layer menu, choose New, then Layer. Control layer attribute (Normal, Soft Light, Overlay, Vivid Light, etc.) by selecting the desired option in the Layers palette. You can hide a layer by clicking on the "eye" icon next to it in the Layers palette.

**photoshop close-up:**

### LAYER IN SOFT LIGHT MODE

**photoshop close-up:**

### BRUSH TOOL IN COLOR DODGE MODE

When the Brush tool is set to Color Dodge mode, it lightens the base art while mixing in some of the chosen foreground color.

Select the Brush tool from the Tools menu and pick a round brush, either soft or hard. In the top menu bar, click on the tab next to Mode, scroll down, and pick Color Dodge.

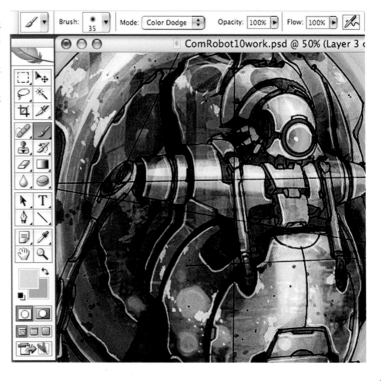

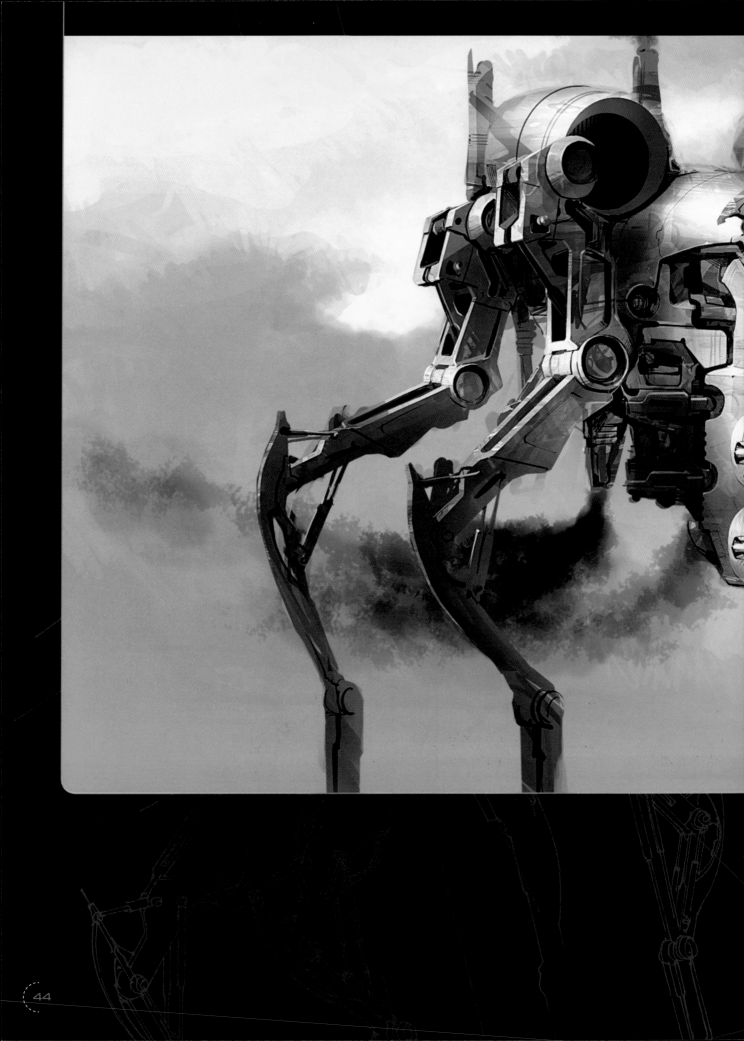

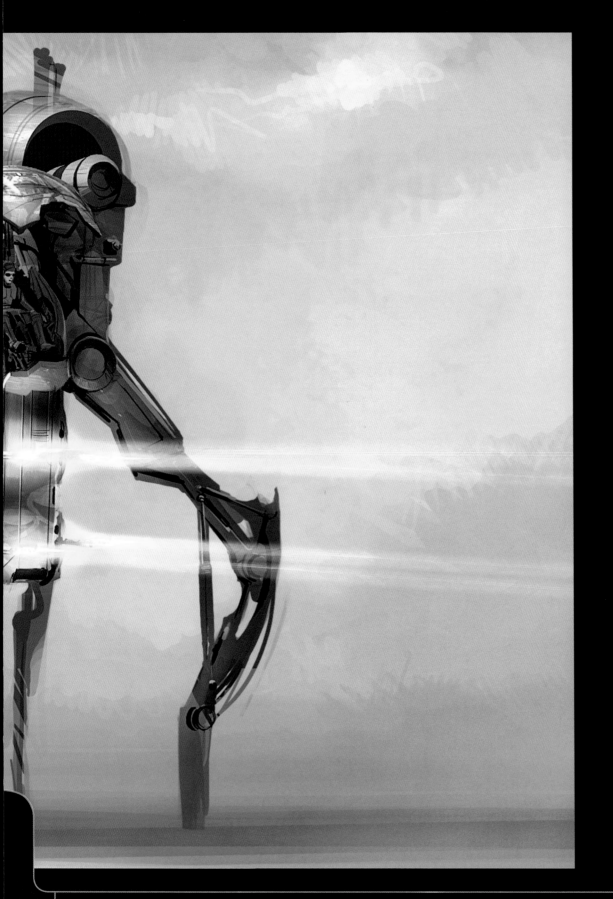

# WALKING MACHINES AND TRANSPORTS

# C-1 military robot

One of my favorite techniques is free-form designing. I start with only a vague idea of what I want to do—in this case, a large military robot. I purposely don't plan ahead, because I want the drawing to evolve and take on a life of its own, leading me in unexpected directions.

## SURFACE
Premium white 28-lb. (105gsm) color copier paper, 11" × 17" (28cm × 43cm)

## MARKERS
Cool Grey 30%, 50%, 60%, 70%

## OTHER
8-inch (20cm) 45°/90° plastic triangle with inking edge
12-inch (30cm) metal ruler
Air marker system
Daler-Rowney Pro White opaque watercolor paint
Fine-tip black pen
Pointed round kolinsky sable brush, 1/16" (2mm) diameter
Small and large ellipse guides, sizes 10°–80°

### STAGE 1 Sketching

Using the Cool Grey 30% marker, start sketching shapes, any shapes. Eventually I ended up with an armored turtle-like machine. This was a good start, but I thought the overall proportions weren't unique.

### STAGE 2 Continued Exploration

I made the body more dome-shaped, with a central eye in the front to give it direction. This was better but the overall shape was still rather bland. I kept the single eye but moved it up to the top of the body, then made the body taller and narrower. Immediately, the new silhouette was more interesting. At this stage, notice how all the marker lines from the trial-and-error explorations have created positive and negative shapes.

### STAGE 3 Construction Lines and Defining Details

With a fine-tip pen, draw in construction lines to anchor the amorphous marker sketch and give it structure. Working from front to back, start the detailed pen work, outlining the vague marker shapes. I turned mine into hinges, joints and, finally, a leg.

### STAGE 4 Final Detailed Lines

Sometimes it's hard to see all the shapes immediately. Keep moving around the drawing; this will ensure you don't overwork any particular section. Complete the final details, but leave the two far legs unfinished. This allows the viewer's imagination to fill in what is not drawn, keeping the drawing fresh and interesting.

### STAGE 5 Adding Tones

With the Cool Grey 30%, 50%, 60% and 70% markers, start adding tones, working from front to back, large areas to small. Note that you're adding the tones from front to back instead of back to front in this case because the dark tones of the shadow areas will clean up marker bleeds and help define the leg shapes.

Move fast so the markers don't dry out between applications. Stages 5 and 6 should be finished in less than twenty minutes.

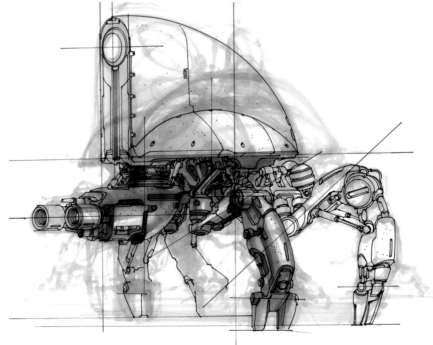

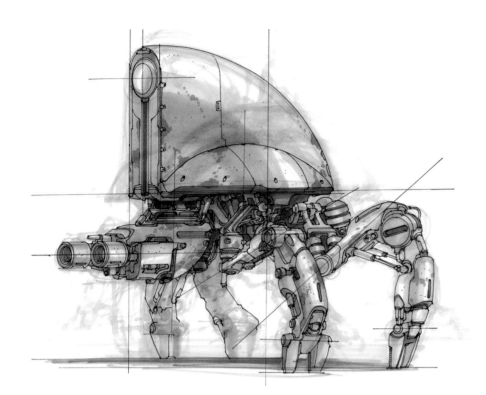

**STAGE 6** Finished Tones

Finish adding tones, but don't add tone to everything. Notice again that the two far legs are left unfinished. This, in combination with the original markers from Stages 1 and 2, keeps the drawing loose and alive.

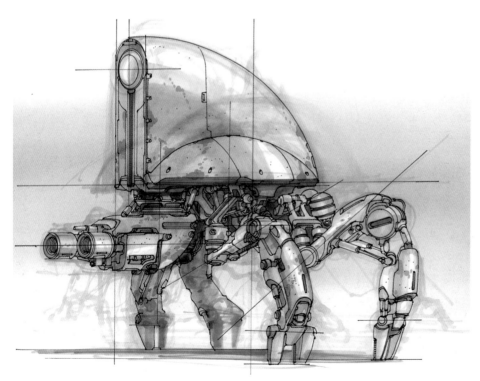

**STAGE 7** Adding a Background Gradation

Sometimes, all the exploration can get messy, so it's necessary to unify the drawing. Do this by adding a simple background gradation using the Cool Grey 70% marker with an air marker system.

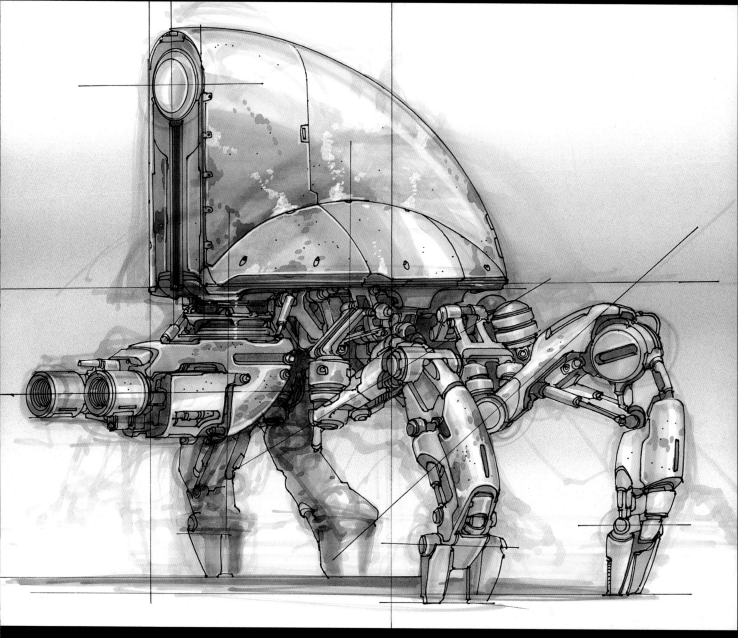

## STAGE 8 Adding Highlights

As a final touch, add highlights with Pro White. The highlights lend
extra detail and a sense of dimension to the form. You can also use
Pro White to clean up edges if necessary, but use it sparingly. It is not
meant to be an eraser.

# steambot

Mixing machine technologies from different eras can be a great source of inspiration for unique robot designs. Combining eighteenth-century technology with twentieth-century mechanics, for example, creates fantastic design opportunities. In reality, a steam-powered robot doesn't make much sense. But visually, it's very striking.

**SURFACE**
Premium white 28-lb. (105gsm) color copier paper, 11" × 17" (28cm × 43cm)

**MARKERS**
Cool Grey 30%, 50%, 60%, 70%

**OTHER**
8-inch (20cm) 45°/90° plastic triangle with inking edge
12-inch (30cm) metal ruler
Air marker system
Daler-Rowney Pro White opaque watercolor paint
Fine-tip black pen
Pointed round kolinsky sable brush, 1/16" (2mm) diameter
Small and large ellipse guides, sizes 10°–80°

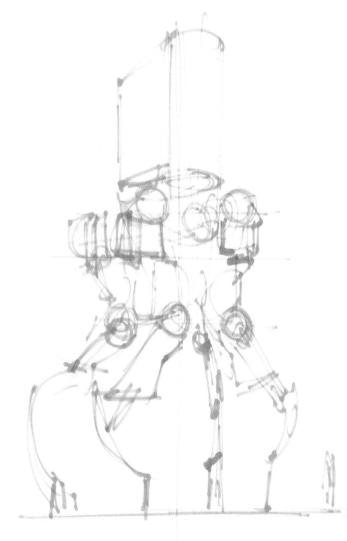

### STAGE 1 Marker Sketch

Imagine a tall, spidery robot with a steam boiler on top. With this idea in mind, begin lightly sketching with the Cool Grey 30% marker. Think about the overall proportions, not the details. This first stage should be very rough and very quick. Note that I've added a person to give us a sense of scale.

### PERSPECTIVE HINT

A carefully placed human figure in a drawing of machinery can provide the viewer with instant perspective and scale, since we all know how big a person is. This simple addition also makes the design seem more real by serving as a point of reference to our world.

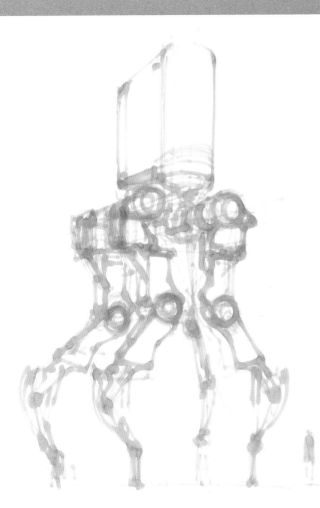

## STAGE 2 Tighter Marker Sketch

With the basic proportions determined, continue drawing with the Cool Grey 30% marker. Working more slowly, focus on the legs, sketching out the general shapes, then figuring out how they function. I settled on the idea of interlocking scissor mechanisms as the basis for the leg design.

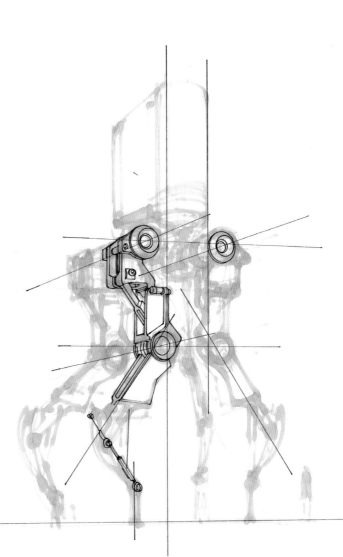

## STAGE 3 Establishing Perspective Lines and Legs

With the fine-tip pen and the triangle, draw the main perspective lines. Then use the small ellipse guides to start adding the ellipses for the leg. Next, begin to pull out shapes and details from the vague marker blobs and turn them into specific machine parts.

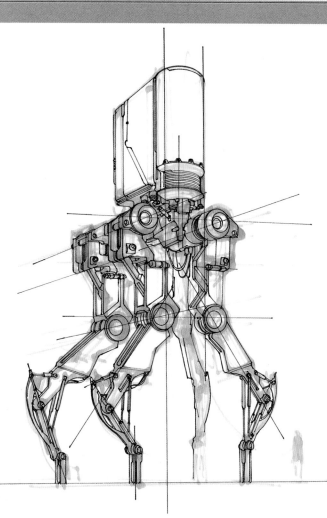

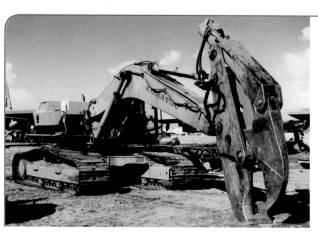

### STAGE 4 Finished Line Work

This stage is the most demanding. Continuing with the fine-tip pen, move around the design defining all the mechanical parts. Because the leg mechanism is key to the overall success of this design, it needs to be figured out in great detail. (See the construction equipment photo at top right for reference.)

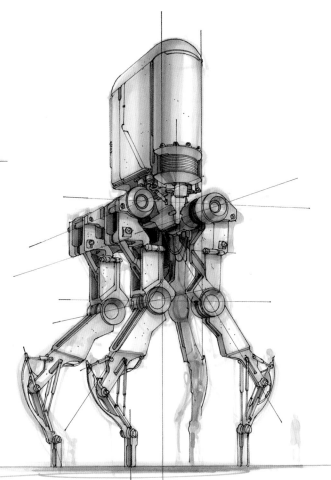

### STAGE 5 Tone Marker Finish

Block in the major tones first, working from round shapes to flat forms, large shapes to small. Here, the biggest round form is the boiler on top. Start there and move down. Don't marker the entire drawing to the same level of finish. Here, the front two legs are finished, the third is nearly finished, and the fourth is only suggested.

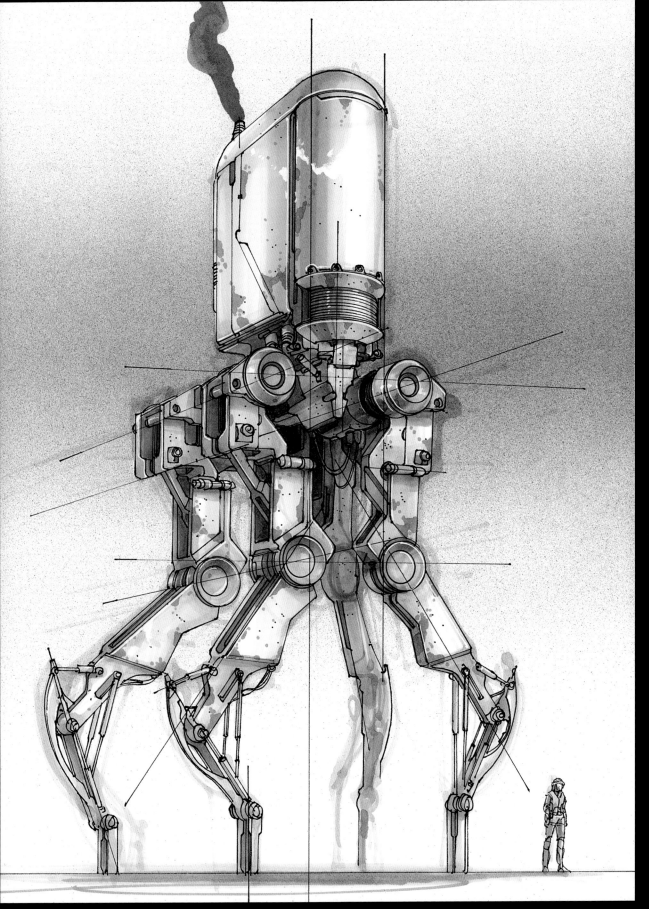

## STAGE 6 Highlights and Background

As you finish the figure, marker tones and smoke, punch up the robot with corrosion effects by layering wet markers on top of dry ones to create hard edges (see page 56). Add Pro White highlights. Use an air marker system with the Cool Grey 70% to create the background, making sure to mask the robot as you did on page 25. This texture will enhance the gritty, low-tech quality of the machine.

# tankk

I tend to prefer walking vehicles over wheeled ones. For this demo, I wanted to create a mobile armored fighting machine based on the concept of a walking personal infantry tank.

## SURFACE

Post-it note pad, 3" × 3" (8cm × 8cm)
Premium white 28-lb. (105gsm) color copier paper, 11" × 17" (28cm × 43cm)

## MARKERS

Black; Cool Grey 30%, 50%, 60%, 70%

## OTHER

8-inch (20cm) 45°/90° plastic triangle with inking edge
12-inch (30cm) metal ruler
Air marker system
Blueline pencil
Daler-Rowney Pro White opaque watercolor paint
Fine-tip black pen
Pointed round kolinsky sable brush, 1/16" (2mm) diameter
Small and large ellipse guides, sizes 10°–80°
White vinyl eraser

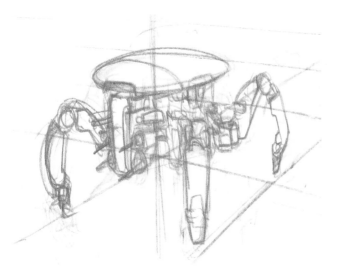

**STAGE 1** Preliminary Thumbnail Sketch

Do small sketches with blueline pencil on Post-it notes, beginning with perspective lines as you did on page 29. Instead of placing the guns on top, I thought it would be more interesting to put them down low and create the appearance of a face.

**STAGE 2** Marker Sketch

Re-draw your favorite thumbnail sketch on color copier paper using the Cool Grey 30% marker. Make subtle refinements until the proportions look right to you. Add a top hatch and a pilot for scale.

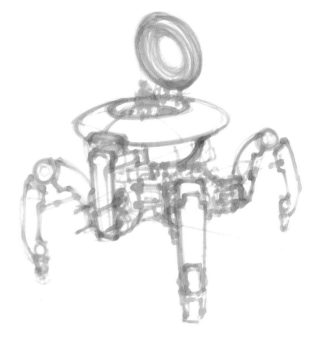

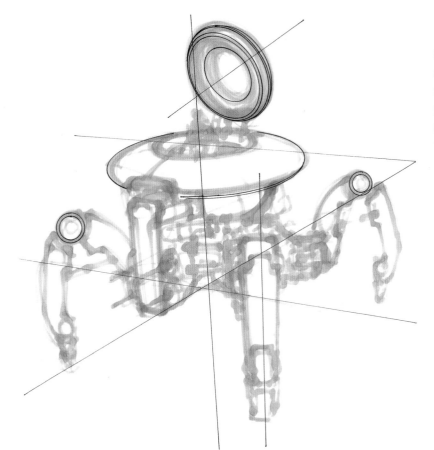

**STAGE 3** Perspective Lines and Major Ellipses

Using the triangle and pen, lay in the major perspective lines. Then, with the large ellipse guide, draw in all the large ellipses to anchor the drawing. Do this before any detail work.

**STAGE 4** Detail Work

The center of interest is the pilot. Define him first, making sure he is seated properly in the machine. Moving down from there, define the next area of interest, the machine's head.

DESIGN TIP

Defining the details in the order of visual interest is always a good idea; that's how the viewer will see the design. Typically, the center of interest will be around the design's perceived "head" or around the person in the design, if there is one.

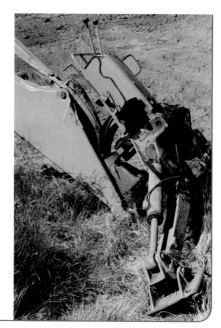

**Stage 5 Reference Photo**

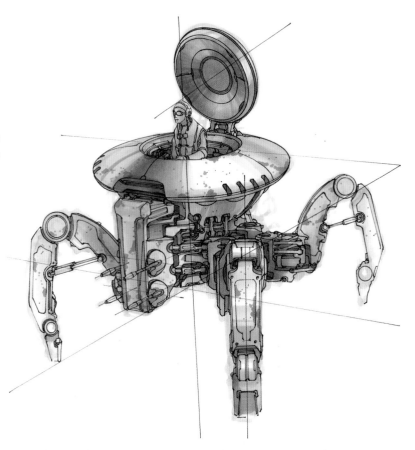

### STAGE 5 Finished Detail Work

I referenced the hinge joint of a backhoe tractor for the leg joints. Using the fine-tip pen, define the mechanics of the legs using the reference photo as inspiration. But don't copy the photo exactly. Invent as you draw.

### STAGE 6 Finished Marker Tones

Add tone with the markers. Wait until the markers are dry, then use the Cool Grey 60% marker to create corrosion effects on the machine.

### EASY CORROSION EFFECTS

Adding fresh markers on top of dry ones will create hard edges—something you normally don't want, but they're great for corrosion effects.

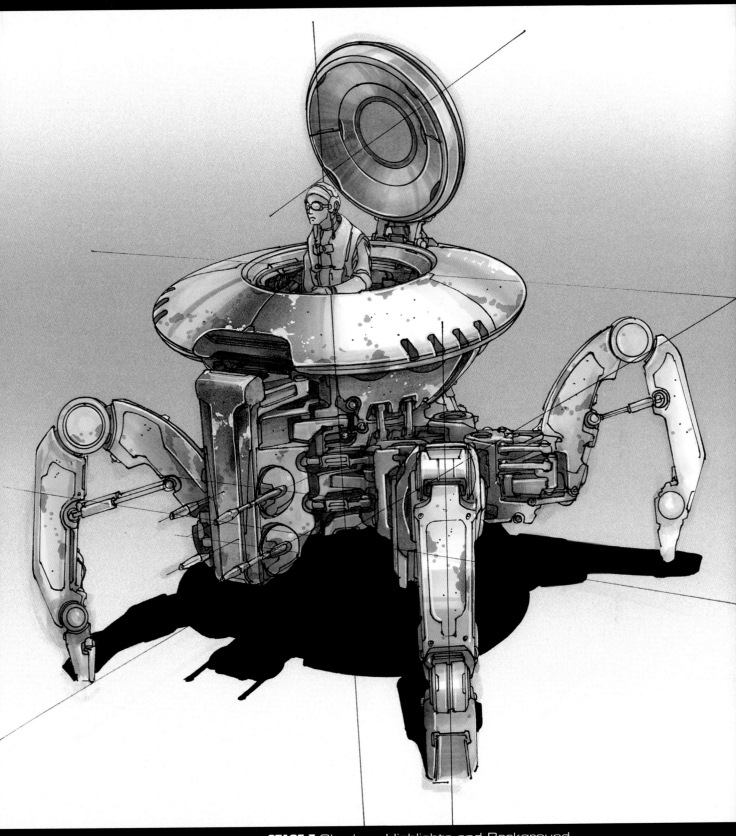

**STAGE 7** Shadow, Highlights and Background

# massive T

Mixing two distinct machine forms creates strong hybrid designs that are often more interesting than the originals. This is a great way to design science-fiction vehicles. For this demo, I designed a very large land transport vehicle by combining the aesthetics of steam locomotives and heavy construction trucks.

**SURFACE**
Premium white 28-lb. (105gsm) color copier paper, 11" × 17" (28cm × 43cm)

**MARKERS**
Cool Grey 30%, 50%, 60%, 70%

**OTHER**
8-inch (20cm) 45°/90° plastic triangle with inking edge
12-inch (30cm) metal ruler
Blueline pencil
Computer with Adobe Photoshop
Daler-Rowney Pro White opaque watercolor paint
Fine-tip black pen
Pointed round kolinsky sable brush, 1/16" (2mm)
Small and large ellipse guides, sizes 10°–80°
White vinyl eraser

**STAGE 1** Blueline Sketch

Block in the basic shapes on color copier paper using the blueline pencil. Take steam driver pistons like those on an older locomotive and enlarge and re-position them into a V-6 car engine configuration. Around those, add the boiler and coal car, then truck wheels. This odd mix of elements creates a very interesting transport.

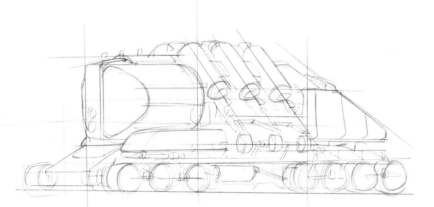

**STAGE 2** Completion of Blueline Sketch

Since this vehicle is complex, take your time and be more thorough in this stage. Use the small ellipse guides early to draw the wheels and pistons correctly. If all these moving parts are drawn sloppily, the locomotive design will not be convincing. Working out all the details now will make the final inking easier.

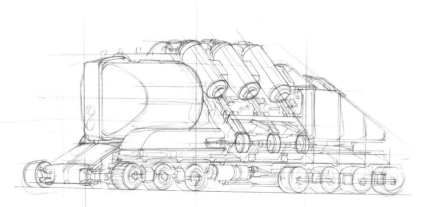

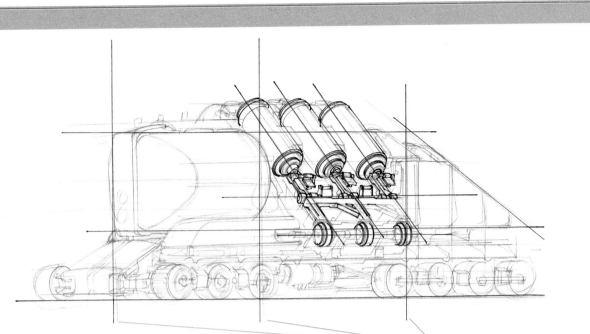

## STAGE 3 Perspective and Ellipses

Redraw the perspective lines in ink. Notice that I have corrected small perspective errors from the blueline sketch. Such errors become more pronounced when the drawing is finished, so catch them now. Because the engine details demand more precision, use the small ellipse guides to draw all the ellipses for one area before drawing the nonellipse shape details. Put in all the ellipses for the pistons before inking the connecting components.

Notice that I've corrected the blue perspective lines with more accurate pen lines.

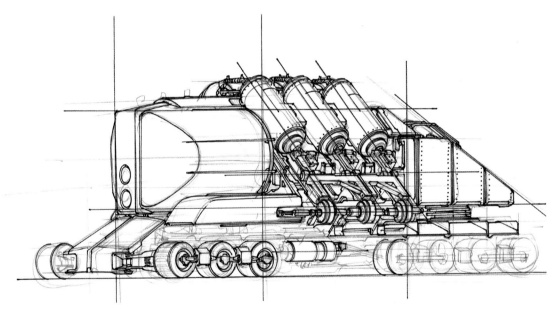

## STAGE 4 Defining Details

Move around the drawing, using the ellipse guides to define the large cylindrical shapes. Then ink in the smaller, more complicated details freehand. This is very time-intensive but necessary, because every part needs to be figured out and drawn properly. Take the time to do it right.

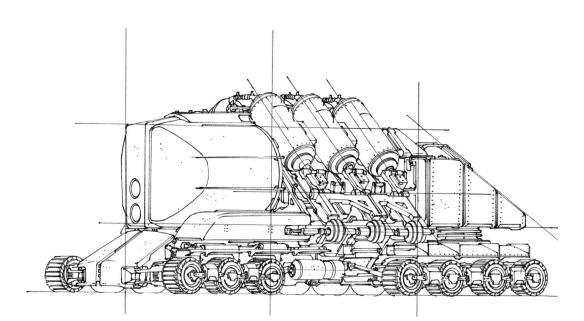

## STAGE 5 Checking the Details

Using the white vinyl eraser, erase all the blueline pencil marks. After all the bluelines are removed, check to make sure the drawing is reading well. Look for areas that need more definition or areas that need shape adjustments. Judge the overall form for visual balance, proper perspective and proper proportions. The form should be clearly delineated by this stage.

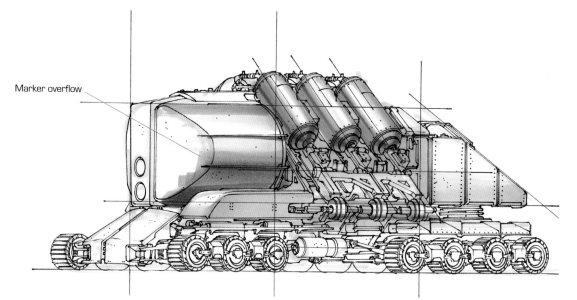

Marker overflow

## STAGE 6 Adding Tones

With the Cool Grey 30%, 50%, 60% and 70% markers, begin blocking in the tonal values. Do the large round shapes before the flat ones. Round and cylindrical shapes require more mixing of tones than flat shapes do, so working them first allows you to correct overflow. For example, notice the front flat piece of the boiler. My markers have overflowed into this front planar section, but that's okay. It'll be corrected when I add tone over this part.

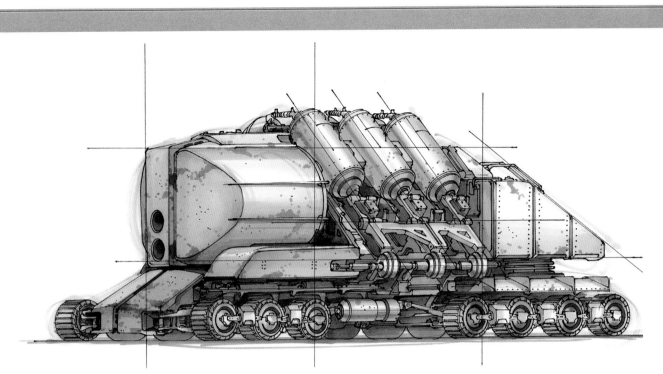

## STAGE 7 Finishing Tones

Finish the marker tones. You can see that the overflows from Stage 6 have been covered up and corrected by subsequent markers. It'll take practice, but eventually you'll understand which shapes need to be toned first. Usually, you'll want to work from big areas to small, round shapes to flat, background to foreground.

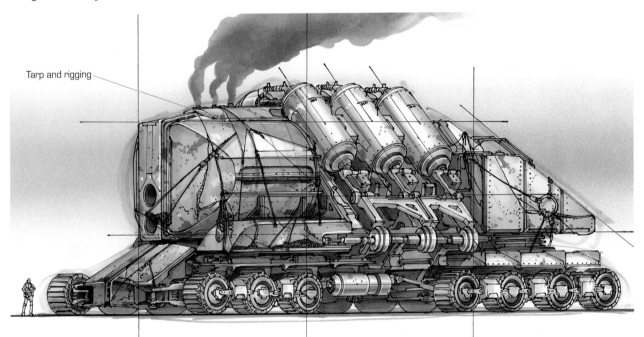

Tarp and rigging

## STAGE 8 Highlights and Finishing Details

Add a person for scale. Ink a few last-minute details to give the vehicle more interest, then put in highlights with Pro White. Since the boiler was a big, simple shape, I added a tarp and some rigging to make the area more visually exciting.

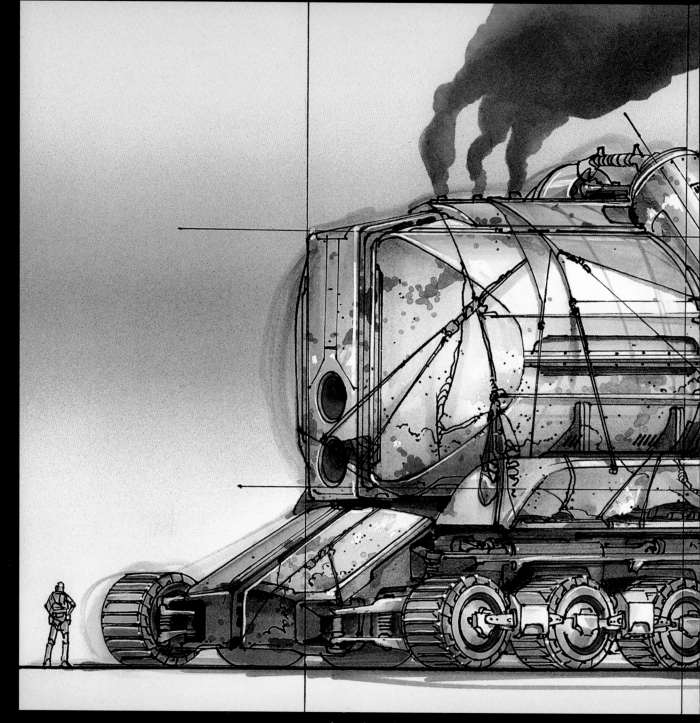

## BRUSH TOOL IN COLOR DODGE MODE

Use a 360-pixel brush size in Color Dodge mode to brighten highlights on the drawing. Since highlights are lighting effects that alter the overall image, don't use masks to contain them. For more about the Color Dodge brush mode, see page 43.

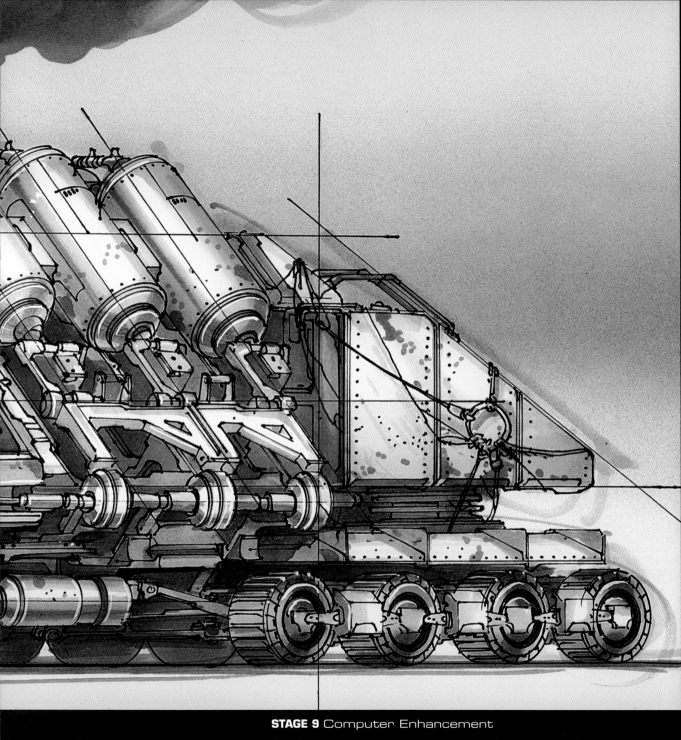

**STAGE 9** Computer Enhancement

Scan the finished drawing into the computer. Use Photoshop to tint the image. Then, with the *Brush tool in Color Dodge mode*, add highlights to the boiler and pistons to give the

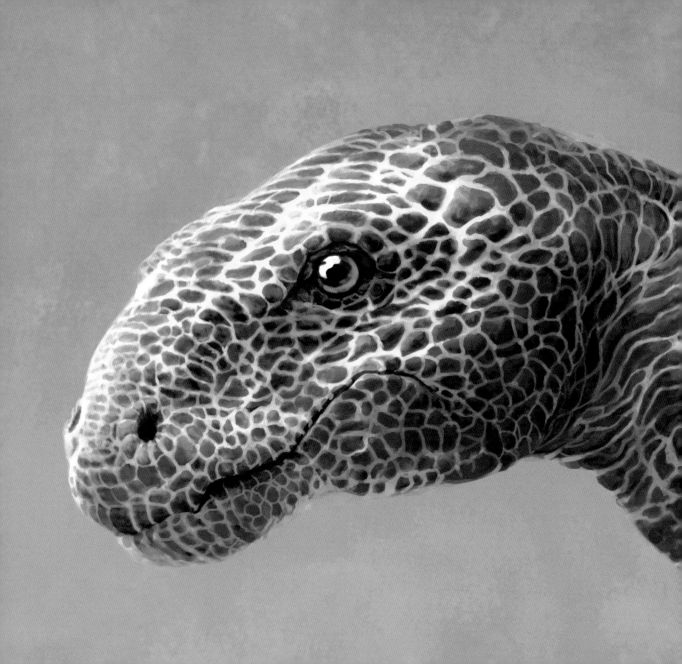

# labor beast

Designing exotic creatures is about not straying too far from reality. Small alterations to familiar objects are all you need to create exotic designs. Restraint is often the secret.

## SURFACE
Premium white 28-lb. (105gsm) color copier paper, 11" × 17" (28cm × 43cm)

## MARKERS
Cool Grey 30%, 50%, 60%, 70%

## OTHER
8-inch (20cm) 45°/90° plastic triangle with inking edge
12-inch (30cm) metal ruler
Air marker system
Blueline pencil
Daler-Rowney Pro White opaque watercolor paint
Fine-tip black pen
Pointed round kolinsky sable brush, 1/16" (2mm) diameter
Small and large ellipse guides, sizes 10°–80°
White vinyl eraser

### STAGE 1 Thumbnail Sketch

Sketching small, 3" × 2" (8cm × 5cm), rough in the basic shape of a camel-like beast of burden. The large, bony hump allows this creature to carry heavy loads, and the small head gives it a benign personality.

### STAGE 2 Blueline Sketch

Re-draw the beast larger on color copier paper, focusing on its powerful legs. Working at a larger size will allow you to delineate the beast's harness and impossibly large payload in greater detail. Perspective lines aren't really necessary for creature designs. I have replaced them with construction lines for the shafts of the harness.

Construction lines

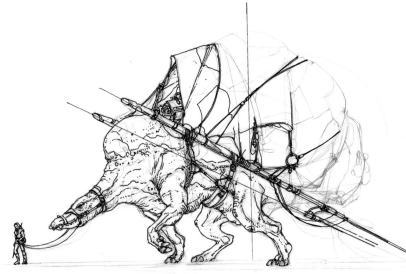

### STAGE 3 Defining Details

Start detailing with pen. When designing creatures, you want to keep line qualities organic. To do this, hold the pen gently to allow for slight line variation. This will prevent the drawing from looking too mechanical and rigid.

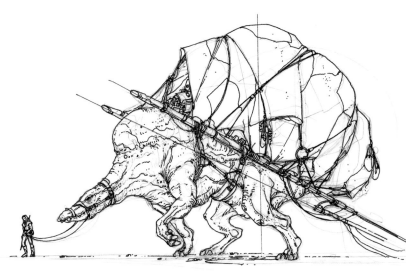

### STAGE 4 Final Line Work

Finish defining the details. The line quality can also suggest the hardness or softness of the material. Stroke harder and quicker for hard surfaces and more gently and slowly for soft, organic material.

### STAGE 5 Erasing the Pencils

Erase the blue pencil lines using the white vinyl eraser. Double-check the drawing to make sure the proportions and details are delineated properly. If you find a minor error, correct it with more pen work. Bigger errors will have to be corrected by cutting and pasting in a new section (see page 36 for the technique). In either case, don't use Pro White to cover up any line errors, since the gray markers in the next stage won't apply properly over it.

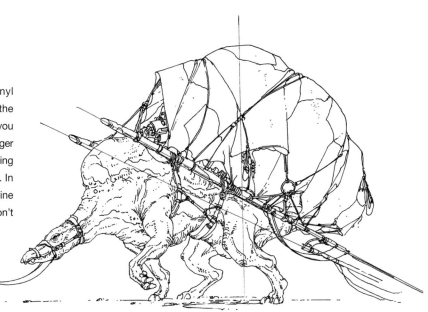

**STAGE 6** Marker Tone

Using the gray markers, begin adding tone. Speed
is not as critical with creature markering as it is with
man-made surface markering since the various tones
don't have to blend as smoothly. Mottled, hard edges
between tones can be desirable on organic surfaces,
such as on this beast's rough skin.

**STAGE 7** Continuing Marker Tone

During the final tone application, squint your eyes
as you marker to ensure that the forms are reading
well. When you squint, you'll see only the major
shapes and values. If those look right, your design
is working.

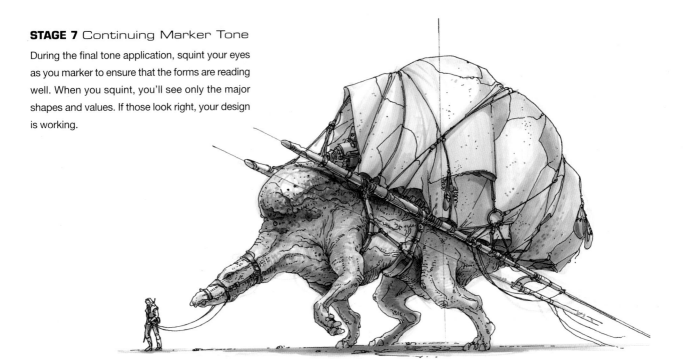

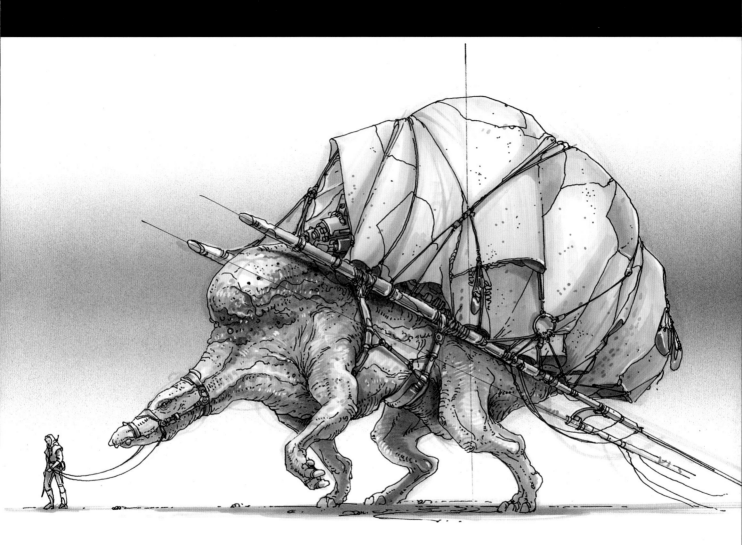

**STAGE 8** Highlights and Background

Use the Cool Grey 70% marker and the air marker system to airbrush

# alien

I've always been intrigued by ants and other tiny insects. For this demo, I use ants as a starting point to drive the design of an alien creature. However, even though it's alien, it's important to make sure the design doesn't become so alien and grotesque that it is unreadable. One solution to this dilemma is to give the creature personality. In this case, I did it by giving the being a recognizable head.

**TOOLS**

**SURFACE**
Premium white 28-lb. (105gsm) color copier paper, 11" × 17" (28cm × 43cm)

**MARKERS**
Cool Grey 30%, 50%, 60%, 70%

**OTHER**
Computer with Adobe Photoshop
Daler-Rowney Pro White opaque watercolor paint
Fine-tip black pen
Pointed round kolinsky sable brush, 1/16" (2mm) diameter

**STAGE 1** Free-Form Sketching

Begin sketching on color copier paper with the Cool Grey 30% marker. Define the general proportions and underlying shape of the creature. Mistakes at this stage make the drawing more interesting, so explore and experiment freely.

**STAGE 2** Knowing When to Stop

Keep working the drawing and let the marker lines blob together. When you begin to see interesting shapes, it's time to stop—but don't stop too soon, either. If you are not sure, keep sketching.

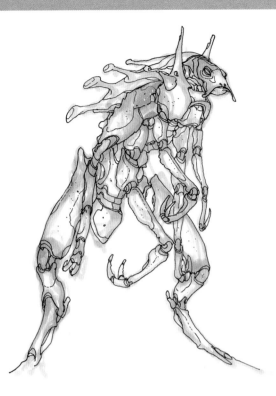

**STAGE 3** Defining Details

Starting at the head and working down, use your black pen to draw the details by outlining the marker shapes. With practice, you'll be able to see distinct forms in the amorphous markers.

**STAGE 4** More Detailing

Continue outlining shapes. Leave some areas of the creature unfinished to keep the drawing alive and fresh. Engage the viewer's imagination to fill in the rest.

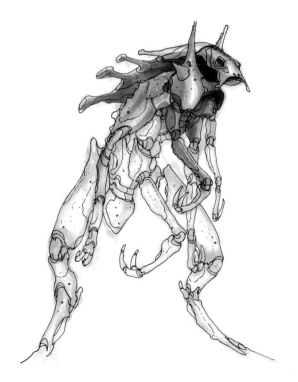

**STAGE 5** Defining Form Through Tones

Determine the direction of the light source, then add marker tones to give volume to the line work. Apply the tones lightly at first so you have room to darken later as necessary. Start from the main area of focus and work outward. For a creature, this is usually the head.

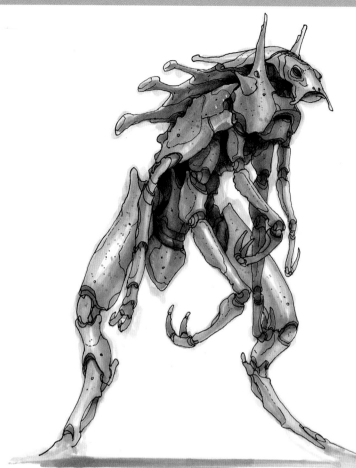

## STAGE 6 Finishing the Form

Squint your eyes as you work to make sure the tones are reading properly. If an area is too confusing, add more dark tones to clarify the shapes. Darker tones create shadows that push the lighter shapes forward.

## STAGE 7 Adding Scale

To make the design more interesting, increase the perceived size of the creature by adding a small human figure. This simple change transforms the creature into something even more exotic and exciting.

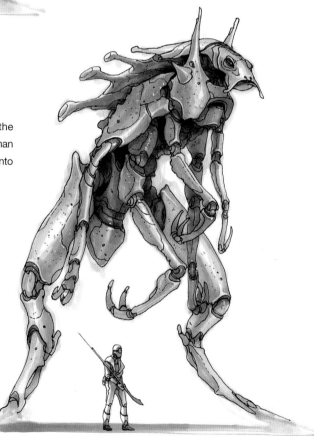

### PHOTOSHOP FUNCTIONS

**CREATING, SAVING AND RETRIEVING MASKS:**
Use the Lasso tool set to 0 pixel feather to outline the area you want to mask. Shift-Lasso to select multiple areas. Then go to the Channels palette and choose Create New Channel from the palette's menu. Choose "Color Indicates Masked Areas," then click OK. With the new channel highlighted in the list, press the Delete key to delete the lassoed area. The mask is now stored in the new channel. Anytime you want to use a saved mask, go to the Select menu, choose Load Selection, and choose the channel you want to load.

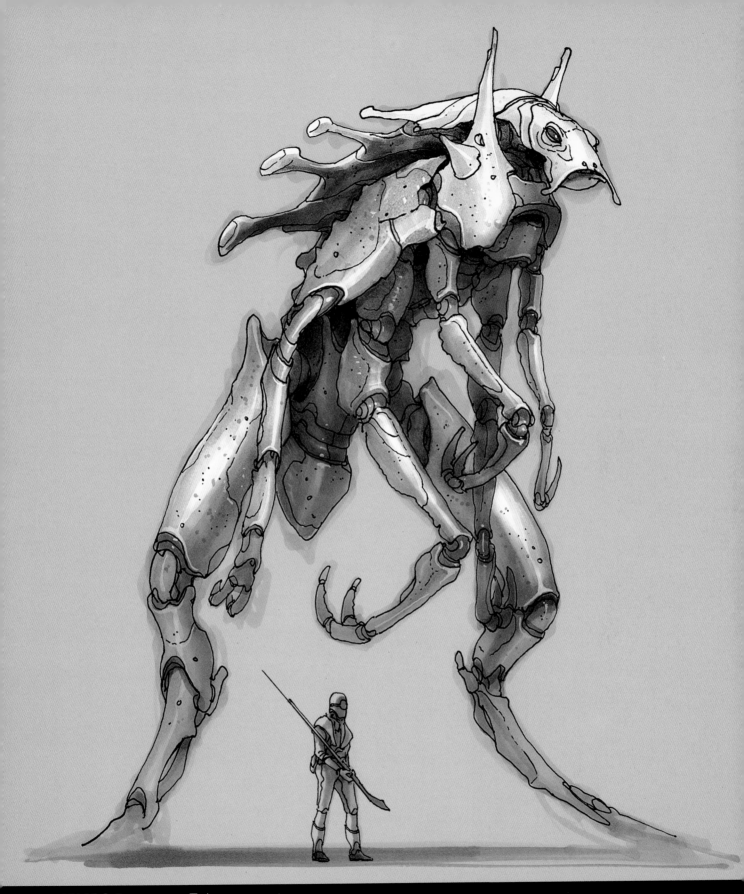

### STAGE 8 Computer Enhancement

Scan the drawing into the computer. Darken and tint the overall image (see page 43). Then, *create a mask* of the creature. Add some simple color effects to only the creature using Photoshop's Brush tool in Color Dodge mode (see page 43) to sweeten the image. This is a simple trick, taking less than five minutes, but it adds pizzazz to the design. However, don't get trapped by this gimmick and overdo it. You can't overcome poor design with flash.

# alien robot

Alien machine designs can easily become abstract and confusing. Strive to keep the overall form easy to understand, even if it's complex. A good test is to see if you can re-draw the final design quickly and with a minimum amount of line work. If this is possible, the design will be understandable.

## SURFACE
Premium white 28-lb. (105gsm) color copier paper, 11" × 17" (28cm × 43cm)

## MARKERS
Cool Grey 30%, 50%, 60%, 70%

## OTHER
8-inch (20cm) 45°/90° plastic triangle with inking edge
Computer with Adobe Photoshop
Daler-Rowney Pro White opaque watercolor paint
Fine-tip black pen
Pointed round kolinsky sable brush, 1/16" (2mm) diameter

**STAGE 1** Rough Marker Sketch

Using the Cool Grey 30% marker, sketch quickly on color copier paper. This robot should be menacing, like a giant skeletal hand.

**STAGE 2** Action Lines and Details

Continue using the Cool Grey 30% marker to define bonelike shapes and joints. Then draw the main action lines using the fine-tip black pen. Perspective lines aren't necessary, but add action lines to give the line work structure.

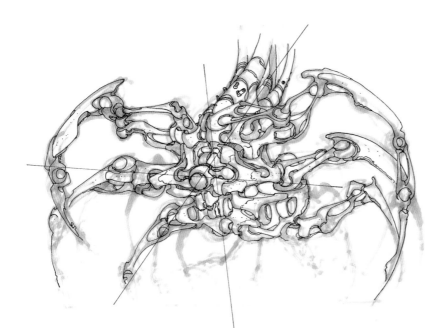

## STAGE 3 Details

Moving around the drawing from the center outward, define the joints. The organic quality of the bonelike joints means you can draw them in a more free-form, and thus more forgiving, manner. Finish the details with the fine-tip black pen. Add more gray tone using the Cool Grey 30% marker to give the drawing more energy.

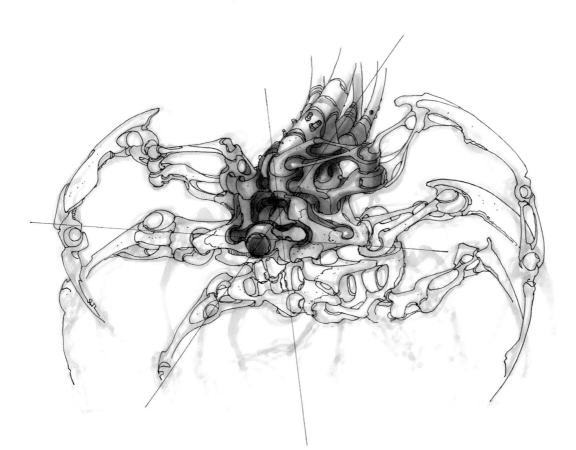

## STAGE 4 Marker Tones

Again, working from the center outward, add tones to define the shapes. Use the full range of Cool Grey 30%, 50%, 60% and 70% markers, and blend the tones evenly.

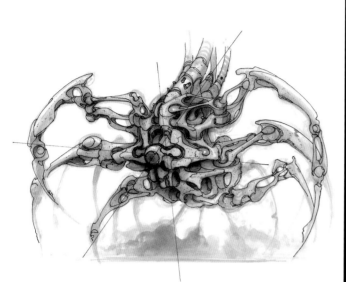

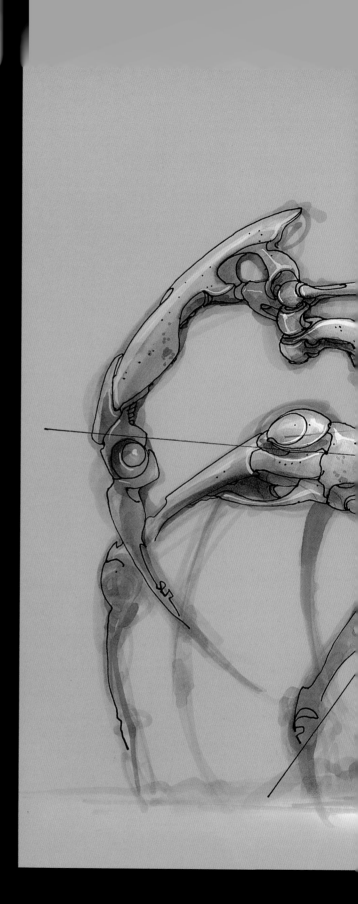

## STAGE 5 Final Marker Tones

Finish the marker tones, then squint to see if they read well. Correct as necessary. Add darker tones to the area around the center eye to define it and make it the center of focus.

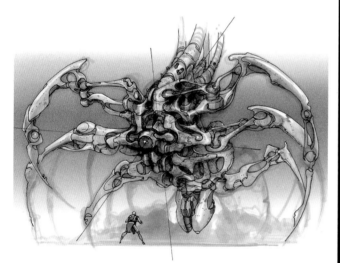

## STAGE 6 Highlights and Background

To complete the design, draw a pincerlike tail on a separate piece of paper (see page 36), then paste it on top of this drawing. Create the background with Cool Grey 70% marker and the air marker system (mask the creature as on page 25).

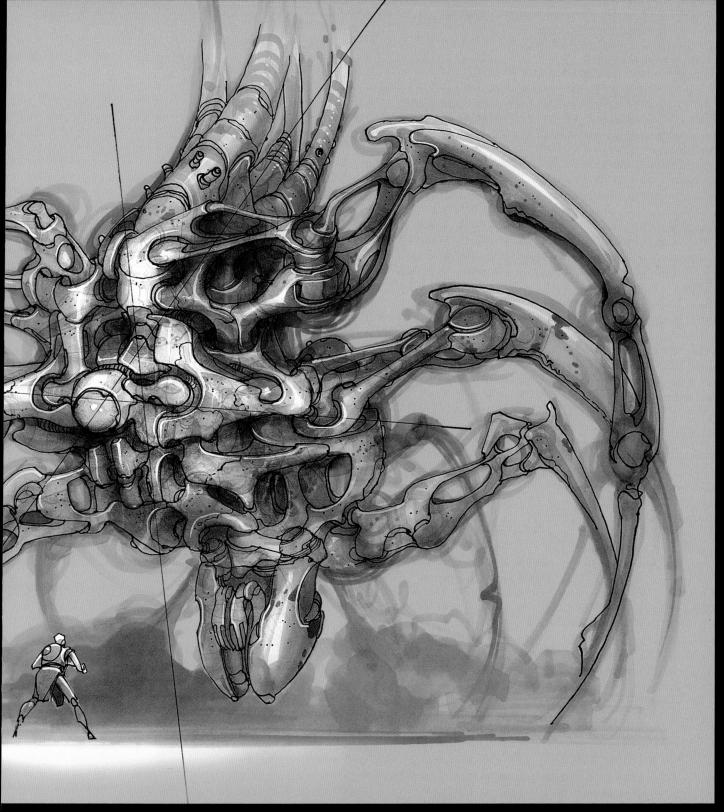

### STAGE 7 Computer Enhancement

Scan the artwork into the computer and open it in Photoshop. Add a
color tint (see page 43), then pull out bright highlights using the Brush
tool in Color Dodge mode (see page 43). This adds a lot of punch to
the drawing.

# dino rider

Both robots and dinosaurs are fantastic subject matter; they make a great visual combination. In this demo, you'll learn how I use the computer and the paint functions in Adobe Photoshop to duplicate a traditional acrylic painting.

**SURFACE**

Premium white 28-lb. (105gsm) color copier paper, 11" × 17" (28cm × 43cm)

**OTHER**

Blueline pencil

Computer with Adobe Photoshop

White vinyl eraser

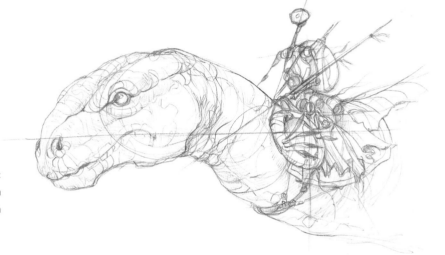

**STAGE 1** Blueline Sketch

Sketch a tight, accurate 7" × 9" (18cm × 23cm) line drawing with blueline pencil on color copier paper. This will be used as an underlay for the digital painting.

**STAGE 2** Background Painting

Scan the line drawing into the computer. Keep your file size big, about 300ppi at 7" × 8" (18cm × 20cm). Open the scan in Photoshop. On a new layer, paint the entire background using the *Brush tool with default settings*. Keep the scanned line drawing as a separate layer (see page 43, Create a New Layer) so you can refer to it as you work.

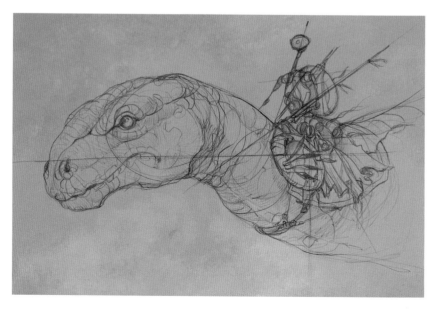

**STAGE 3** Starting the Rough
Color Block-In

Working on a new layer, block in rough colors
using the line drawing as a guide. Precision
isn't an issue, so work loosely and freely.

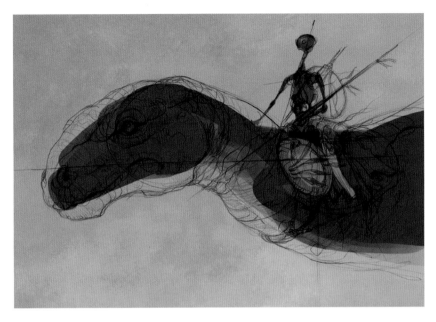

## PHOTOSHOP FUNCTIONS

Refer to this list as needed as you work through the demo.

### BRUSH TOOL WITH DEFAULT SETTINGS:

Click on the Brush tool in the Tool palette. Choose either a hard or soft round brush. Brush opacity is controlled by the
tablet pen pressure. All other functions are set to normal or default. Brush sizes can be controlled manually by picking
different sizes from the menu or by using keyboard shortcuts.

### FLIP IMAGE HORIZONTALLY:

From the Image menu, choose Rotate Canvas, then Flip Canvas Horizontal.

### BRUSH TOOL IN COLOR DODGE MODE:

See page 43.

### BURN TOOL:

From the Tool palette, select the Burn tool. On the default Tool palette, this tool is just below the Gradient tool. Once the
Burn tool is selected, choose either a soft or hard round brush shape for it.

## STAGE 4 Rough Color Block-In, Continued

Refine your rough colors and fill in more of the forms. Use a soft round brush for sketchy sections and a hard round brush for tighter details.

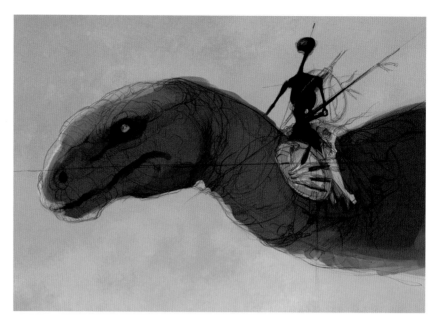

## STAGE 5 Adding Values

Hide the line work layer so you can see the paint work better. Start pushing and pulling the light and dark values of the dinosaur and robot. It's a good idea to move around the painting so you don't get too detailed in any one area.

For the scales, set the Brush tool to a hard edge, and paint in lines to define the scales. Make sure these lines conform to the shape of the creature's structure and are in perspective.

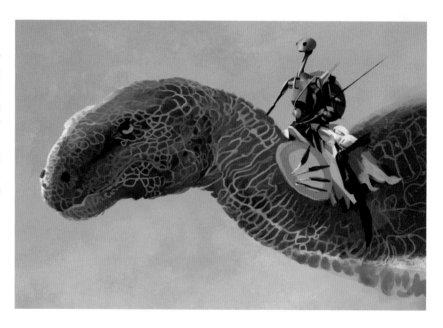

### DESIGN TIP

Flipping the image gives you a fresh view of the painting, and perspective errors or compositional problems can be easily spotted. With traditional painting, you can do this by viewing the work in a mirror. In Photoshop, from the Image menu, choose Rotate Canvas, then Flip Horizontal.

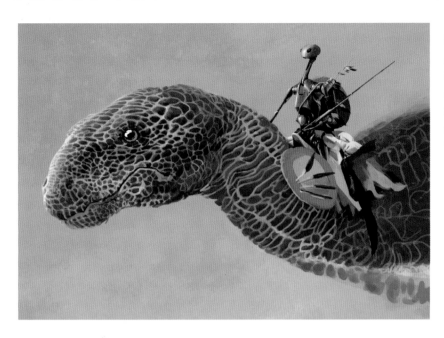

**STAGE 6** More Painting

As the painting comes together, focus more work on the robot and dinosaur head. At this point it's mainly refinement and more refinement. By now, you shouldn't need to refer to the line sketch since the painting has taken on a life of its own.

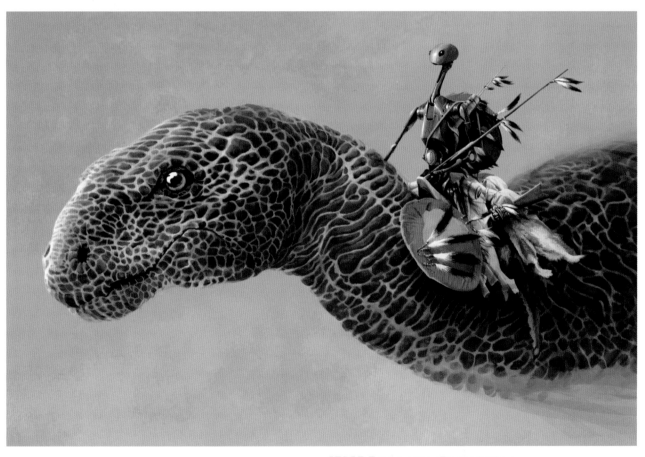

**STAGE 7** Nearing Completion

Continue moving around, refining and repainting to make sure everything is working. Flip the image in the computer often to get a fresh perspective. As in traditional painting, vary the edge qualities and use them to focus the viewer's eyes.

## STAGE 8 Finishing

Up until now, you've been primarily painting with two simple brushes, a hard round and a soft round. This is as close to pure painting as you can get using the computer. But the real power of computer painting is the ability to darken or brighten an entire area and make endless adjustments without repainting. Now, take advantage of some of these abilities by pulling out highlights around the dinosaur's head and darkening the area under the robot. Use the Brush tool in Color Dodge mode (see page 43) for the highlights and the Burn tool (see page 79) for the shadows.

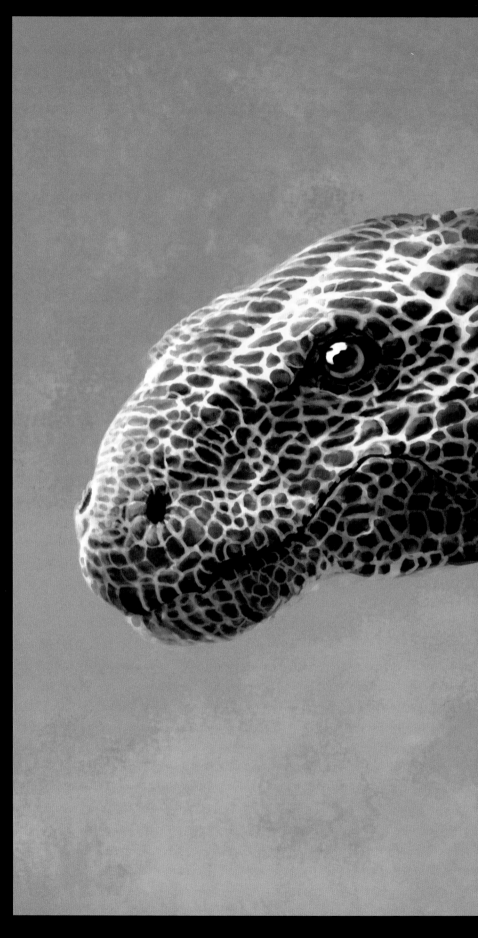

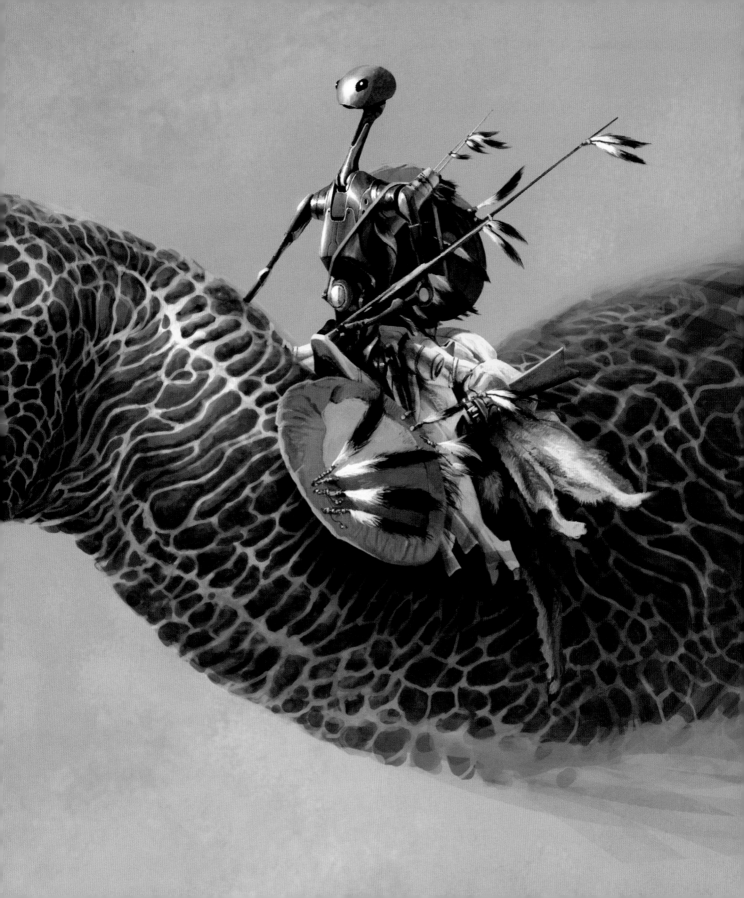

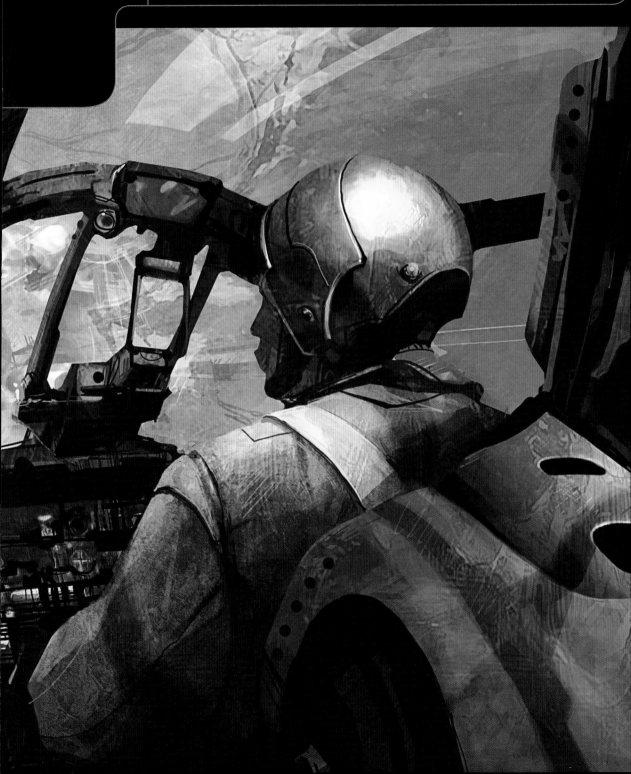

# fighter ship

Small spaceships are improbable machines, but the laws of physics don't play a major role in creating effective designs. Often, dramatic purpose is more important. For example, wings and large cockpit windows really aren't practical in space, but as visual icons they are key to making the design effective.

**SURFACE**

Premium white 28-lb. (105gsm) color copier paper, 11" × 17" (28cm × 43cm)

**MARKERS**

Black; Cool Grey 30%, 50%, 60%, 70%

**OTHER**

8-inch (20cm) 45°/90° plastic triangle with inking edge
12-inch (30cm) metal ruler
Daler-Rowney Pro White opaque watercolor paint
Fine-tip black pen
Pointed round kolinsky sable brush, 1/16" (2mm) diameter
Small and large ellipse guides, sizes 10°–80°

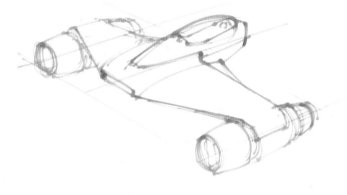

**STAGE 1** Marker Sketch

With the Cool Grey 30% marker, sketch in the basic form. For this spaceship, I kept it simple: two engines and a cockpit. I made it more uncommon by putting the cockpit in the rear, the opposite of modern jet fighters.

**STAGE 2** Perspective Lines

With the triangle and black pen, solidify the perspective lines.

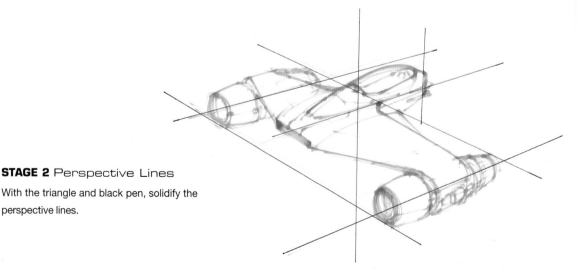

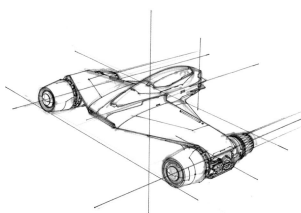

**STAGE 3** Details

Use the triangle to draw the longer straight lines on the ship and free-hand the finer details on the engine. Exposing some of the engine detail adds interest to the design.

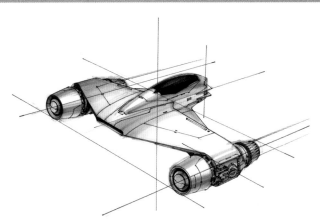

**STAGE 4** Tone Markers

Using the Cool Grey markers, define the form. Keep the foreground wing light while darkening the rest of the ship. This pulls your eyes to the front and gives dimension to the drawing.

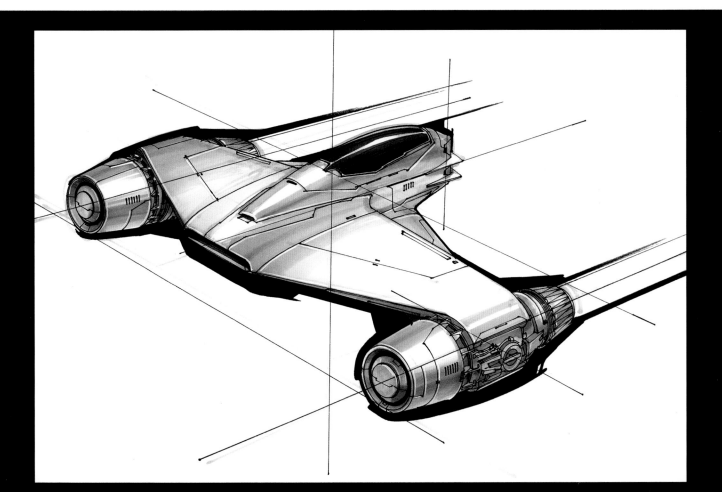

**STAGE 5** Highlights and Black Marker

Add highlights with Pro White. With the Black marker, emphasize the iconic shape of the ship by adding a margin of black around the drawing, making it thickest along the bottom sides of the shapes. This visually grounds the drawing.

# dreadnaught

Like small spaceships, large spaceship designs don't have
to relate to reality. Here visual impact is paramount; it's
more about looking cool than looking real.

**SURFACE**

Post-it note pad, 3" × 3" (8cm × 8cm)
Premium white 28-lb. (105gsm) color copier paper, 11" × 17"
(28cm × 43cm)

**MARKERS**

Black; Cool Grey 30%, 50%, 60%, 70%

**OTHER**

8-inch (20cm) 45°/90° plastic triangle with inking edge
12-inch (30cm) metal ruler
Blueline pencil
Daler-Rowney Pro White opaque watercolor paint
Fine-tip black pen
Pointed round kolinsky sable brush, 1/16" (2mm) diameter
Small and large ellipse guides, sizes 10°–80°
White vinyl eraser

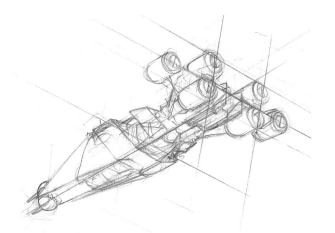

**STAGE 1** Post-it Sketch

Sketch a rough thumbnail on a Post-it note using the blueline pencil.
Six oversized engines give this ship speed, while the wedge-shaped
front makes it aggressive.

**STAGE 2** Detailed Blueline Sketch

Working in blueline pencil on color copier paper,
re-draw your best sketch using the triangle as a
straightedge. Since this design consists mostly of
straight lines, it's better to use straight-edged tools
rather than freehand drawing.

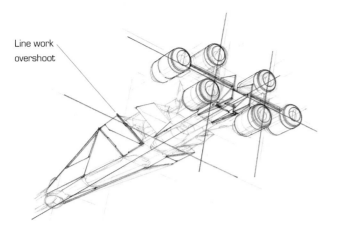

Line work
overshoot

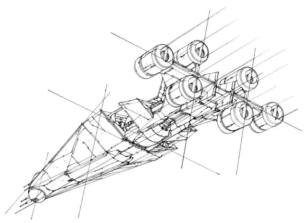

**STAGE 3** Perspective, Ellipses and Details

Define the perspective lines with the triangle and fine-tip pen. Then ink all the major ellipses using the ellipse guides. Again using the triangle, begin inking the main angles. It's OK to overshoot your line work.

**STAGE 4** Final Clean Lines

Erase the blue pencil lines. Double-check the line work for details and perspective. Add additional line work as necessary to clarify the design.

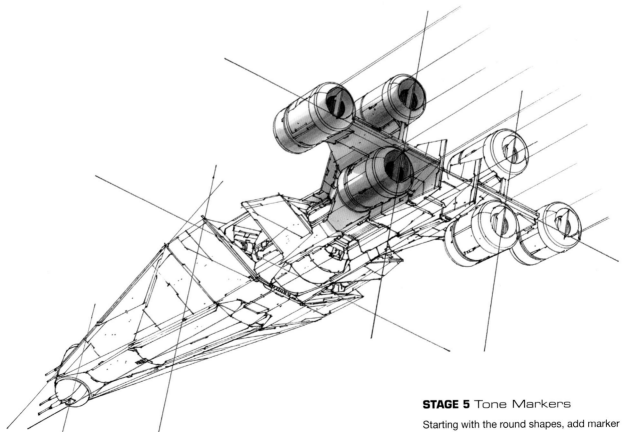

**STAGE 5** Tone Markers

Starting with the round shapes, add marker tones. Notice that I've already identified the light direction by adding a wing shadow to the lower engine.

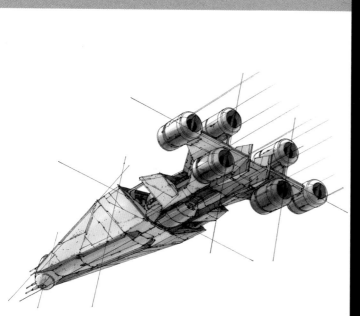

## STAGE 6 Finished Tone Markers

Keep moving around the drawing, adding tones and emphasizing the shadows. Make sure the values are consistent with the light direction so the form reads clearly.

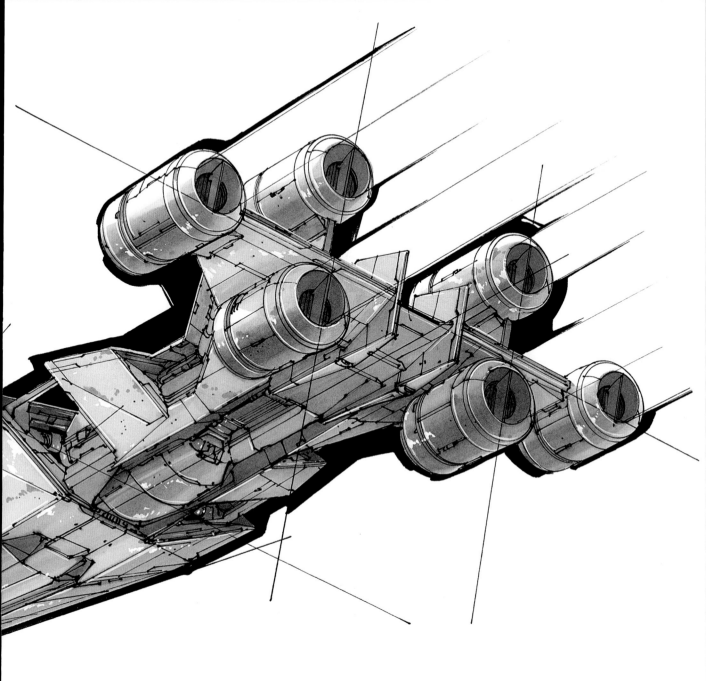

**STAGE 7** Highlights and Black Marker

Use the Black marker around the edges to emphasize the overall shape
as well as to imply engine thrust. The negative shapes are as important
as the positive shapes.

# motoflyer

For this motoflyer, my goal was to combine the concept of a flying motorcycle with low-tech flapping wings. It's an impossible and impractical combination, but one that's visually very striking.

## SURFACE
Premium white 28-lb. (105gsm) color copier paper, 11" × 17" (28cm × 43cm)

## MARKERS
Black; Cool Grey 30%, 50%, 60%, 70%

## OTHER
8-inch (20cm) 45˚/90˚ plastic triangle with inking edge
12-inch (30cm) metal ruler
Blueline pencil
Computer with Adobe Photoshop
Daler-Rowney Pro White opaque watercolor paint
Fine-tip black pen
Pointed round kolinsky sable brush, 1/16" (2mm)
Small and large ellipse guides, sizes 10˚–80˚
White vinyl eraser

**STAGE 1** Blueline Sketch

Sketch the form on color copier paper with the blueline pencil, paying particular attention to the rider. As you build the design around the rider, you'll discover (as I did) that the wing mechanism is more complex and harder to design than one might think. Don't be surprised if you end up reworking this area a lot.

**STAGE 2** Revised Blueline Sketch

For me, Stage 1 turned out to be tougher than I first thought, resulting in a messy drawing. If this happens to you as well, re-draw the design for clarity as I've done. Simply trace over the original sketch, then clean up the lines and work out the rest of the wing mechanics.

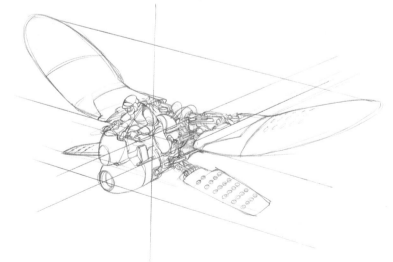

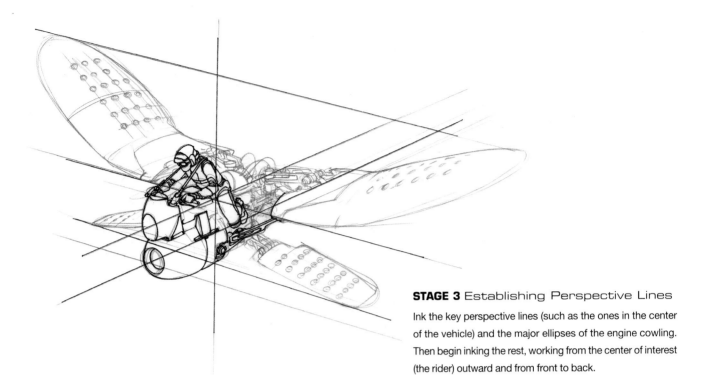

**STAGE 3** Establishing Perspective Lines

Ink the key perspective lines (such as the ones in the center of the vehicle) and the major ellipses of the engine cowling. Then begin inking the rest, working from the center of interest (the rider) outward and from front to back.

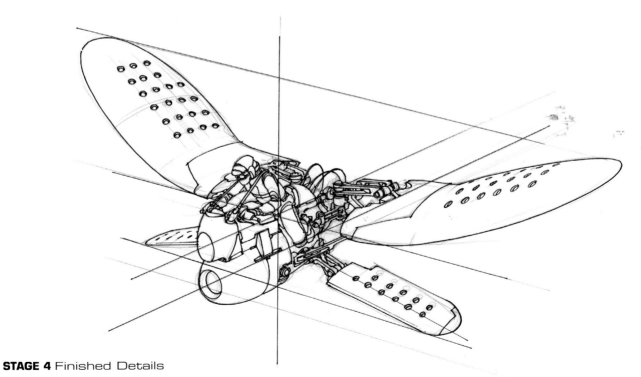

**STAGE 4** Finished Details

To make the wing mechanism convincing, add lots of hinge points. It's OK to make complex mechanisms busy as long as it looks plausible.

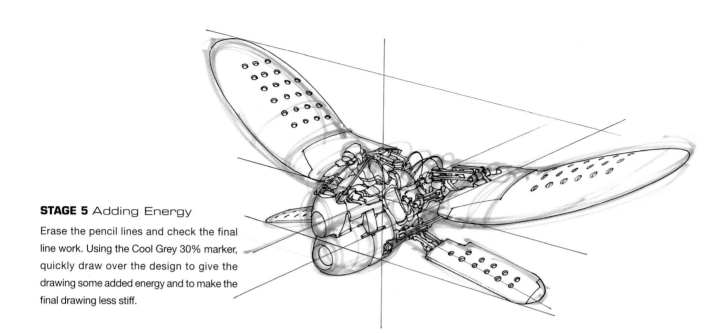

## STAGE 5 Adding Energy

Erase the pencil lines and check the final line work. Using the Cool Grey 30% marker, quickly draw over the design to give the drawing some added energy and to make the final drawing less stiff.

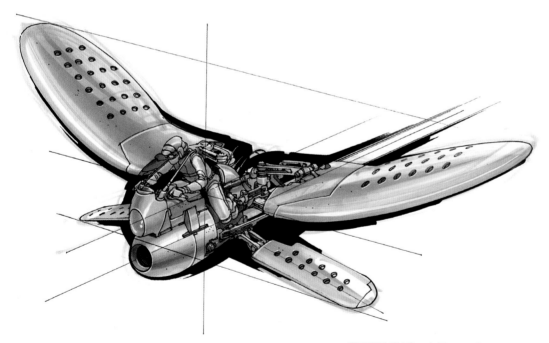

## STAGE 6 Final Tone Markers

Add Black marker around the edges to accentuate the final form. Be careful to not outline the entire drawing, though; and use the black judiciously to define only specific areas of interest.

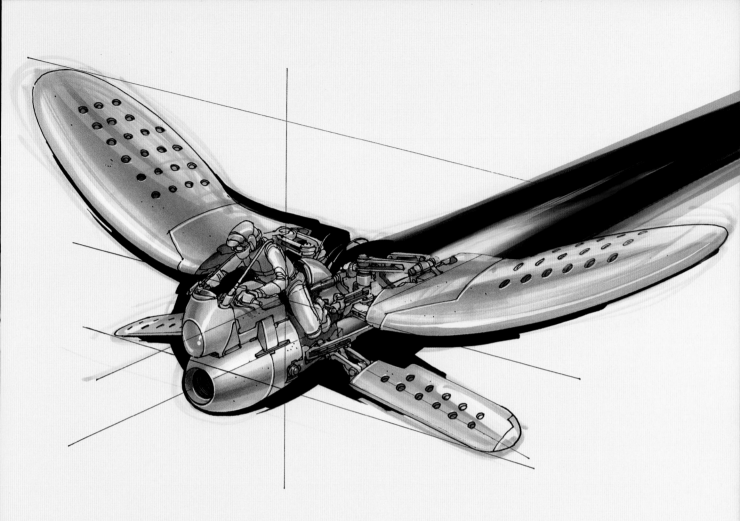

## PHOTOSHOP FUNCTIONS

### SIMPLE JET BLAST OR ENGINE EXHAUST:

I used the hard edge round brush with default settings to paint in the exhaust.

1 Stroke in the jet exhaust area with black. Even though it's only the black background, make sure to paint in perspective.

2 Using the same brush, pick a medium tone orange color to serve as the base color of the exhaust. Paint in the bright orange flames. Use black to feather the exhaust so the orange flame fades properly.

3 Set the Brush to Color Dodge mode and the color to a dark brown and choose a large, soft round brush.

4 Create a mask to contain the glow effect to just the jet exhaust area, and not the vehicle, and brush in the glow effect.

In the Color Dodge mode, experiment with different colors to get different looks. A light yellow color will produce a brighter, white flame while a darker color, like brown, will create a richly saturated yellow-orange flame.

**STAGE 7** Computer Enhancement

Scan the final drawing into the computer and open it in Photoshop. Add a color tint (see page 43) and punch up the highlights using the Brush tool in Color Dodge mode (see page 43). Finally, paint a *simple jet blast*.

# multiwing stealth fighter plane

Designing and rendering sleek, shiny vehicles are tough challenges. Keeping the design clean and having a clear understanding of reflective surfaces are key.

For this demo I'd like to show you one effective technique for rendering shiny machines. I've used this method with traditional art materials in the past; here, I've updated it for use with the computer. The multiwing design will provide lots of nice shiny surfaces to render.

**SURFACE**
Premium white 28-lb. (105gsm) color copier paper, 11" × 17" (28cm × 43cm)

**MARKERS**
Black

**OTHER**
8-inch (20cm) 45°/90° plastic triangle with inking edge
Blueline pencil
Computer with Adobe Photoshop
Fine-tip black pen
Small and large ellipse guides, sizes 10°–80°
White vinyl eraser

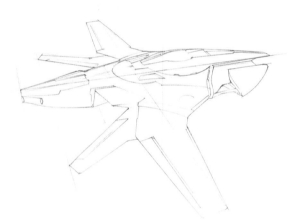

**STAGE 1** Blueline Sketch

Sketch the design on color copier paper, using the blueline pencil and the triangle for the straight lines.

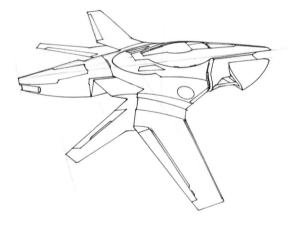

**STAGE 2** Detailed Line Work

Using the fine-tip black pen, draw a clean line version over the blueline pencil sketch. Erase the blue pencil lines, then scan this drawing into the computer and save it as "Stage 2 Scan."

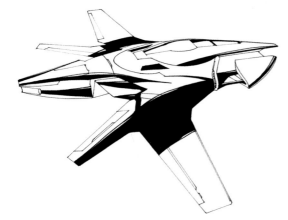

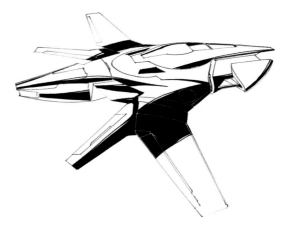

## STAGE 3 Establish the Black Reflections

Return to the original paper drawing and use the Black marker to put in all the dark, hard-edged reflections. Reflective surfaces usually have distinct dark bands that represent the horizon line. In this case, these aren't literal reflections but abstract versions that imply the same thing. Remember, since this is only a design sketch, it is more about perception than reality.

## STAGE 4 Computer Line Work

Scan the drawing again and save it as "Stage 4 Scan." Re-open the Stage 2 scan, then copy and paste the Stage 2 image into the Stage 4 scan. The pasted image will automatically be placed into a new layer.

Now, mix the two images as follows:

1  *Invert the new layer to make it negative.*
2  Change the new layer's mode to Lighten.
3  Change the opacity of the new layer to 50%.
4  Merge the layers.

The result will be white lines in the black reflection area.

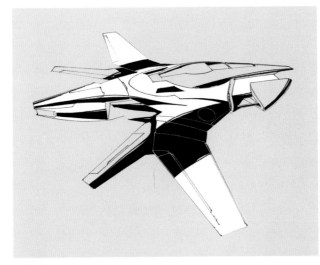

## STAGE 5 Digital Mask

Using the instructions on page 72, create and save a mask to cover the background and certain parts of the plane, as shown here. The blue areas represent the mask. The digital airbrush will affect only the nonblue areas.

### PHOTOSHOP FUNCTIONS

#### INVERT AN IMAGE TO MAKE IT NEGATIVE:

In the Layers palette, click the layer you would like to invert. From the Image menu, choose Adjustments, then Invert.

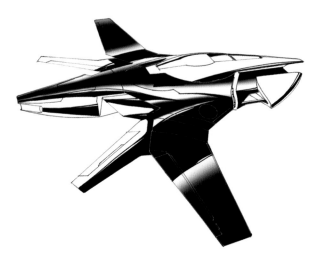

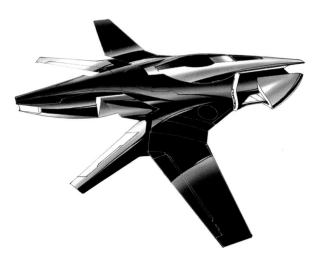

**STAGE 6** Digital Airbrush (Black)

If the mask from Stage 5 isn't still loaded, re-load it (see page 72 for instructions). Select a large, soft round brush from your Brush palette. Using just black, airbrush the sky gradation onto the plane.

**STAGE 7** Digital Airbrush (Colors)

Create and save masks (see page 72) for the parts of the plane you haven't painted yet. Use the same brush setting as in Stage 6 to apply color. Reflective surfaces facing the sun will be warmer and will reflect more of the true local color of the object. Here, I used green and brown. For the far reflection, I used blue to represent the cooler color we typically see in the area of the sky opposite the sun.

**STAGE 8** Final Digital Airbrush

Repeating Stages 5, 6 and 7, paint the other parts of the plane.

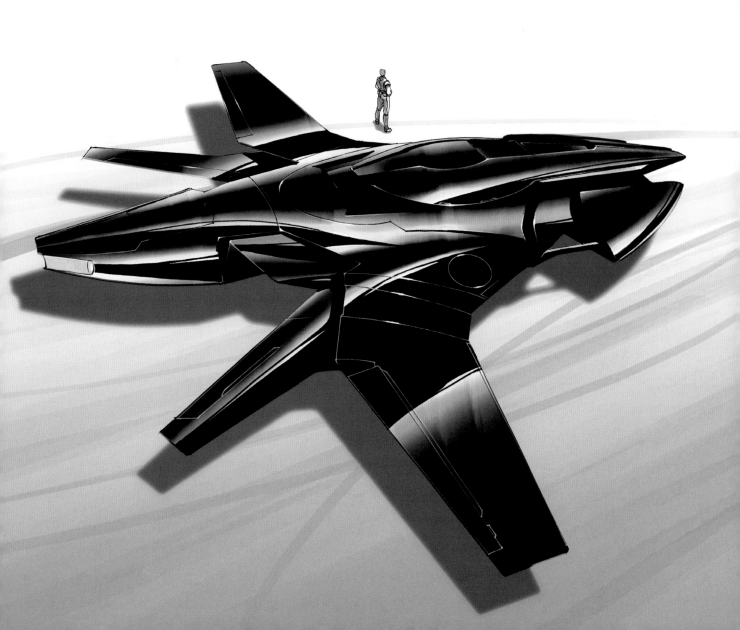

DRAMA AND SCENES:
DIGITAL PAINTING TECHNIQUES

# iron robot

For this demo, follow along as we design and paint a giant iron robot using the computer.

**SURFACE**
Post-it note pad, 3" × 3" (8cm × 8cm)

**OTHER**
Blueline pencil
Computer with Adobe Photoshop

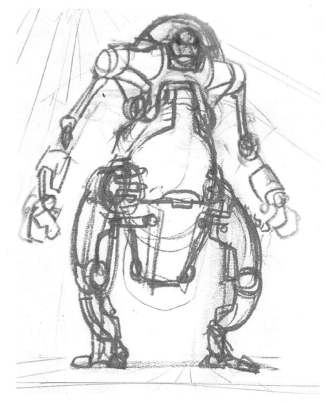

**STAGE 1** Thumbnail Sketch

Using the blueline pencil, sketch a rough design on the Post-it note. Don't worry about details; draw for a strong silhouette.

**STAGE 2** Scanning the Sketch

Scan your best thumbnail sketch into the computer and resize it to the final working size. Mine is 10" × 7" (25cm × 18cm) at 300 ppi resolution. Open the scan in Photoshop.

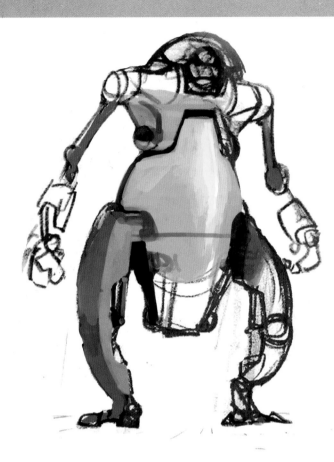

### STAGE 3 Blocking Colors

Create a new layer (see page 43), then use the Brush tool with default settings to begin blocking in the local color of the robot. For this robot, I wanted a shiny brass finish. One of the greatest advantages of painting digitally is ease of color selection. For my brass palette, I sampled various brass textures from photographs and mixed the colors digitally to get the perfect hue.

### STAGE 4 Defining the Joints

Using dark colors, define the leg joints by painting the negative shapes (see page 25). Figuring out form with blocks of color instead of lines is a great alternative design technique.

## STAGE 5 Adding Color

Keep adding color until you've nearly completed the overall color for the robot. Notice the finer details are still missing, but the overall form and color are set.

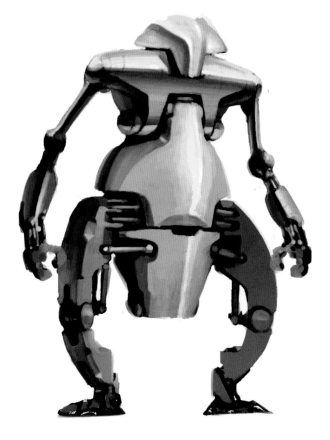

## STAGE 6 Defining Edges and Details

Tighten the paint edges by creating masks (see page 72), then painting within them. To paint the opposing shape, invert the mask by going to the Select menu, then choosing Invert Selection. This will go a long way toward cleaning up the design.

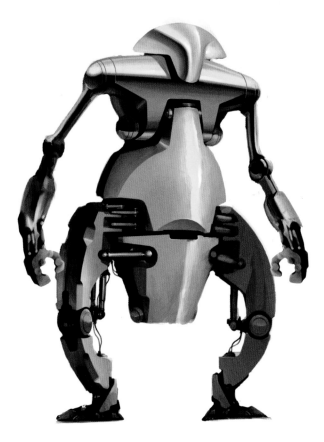

### PHOTOSHOP FUNCTIONS

**ERASER TOOL IN BRUSH MODE:**
Select the Eraser from the Tool palette and change it to Brush mode, then pick a soft or hard round brush shape.

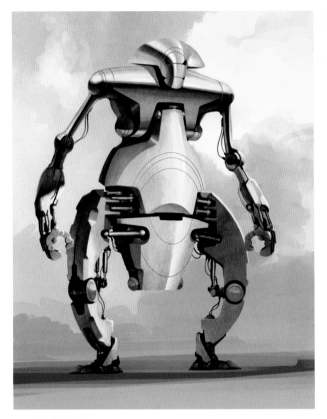

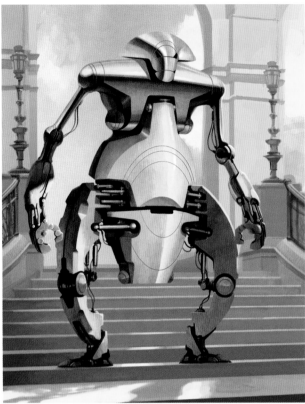

### STAGE 7 Rough Background

Working on the background layer (beneath the robot paint layer), rough in clouds and a ground plane. Add some fine line details to the robot by creating selections with the Elliptical Marquee tool, then choosing Stroke from the Edit menu to "stroke" the selections with black. Add texture by layering a photograph of metal stains over the robot using a new layer in Soft Light mode (see page 43). It's a good idea to maintain a library of textures just for this purpose.

### STAGE 8 More Painting

Add architectural elements to the background to make it more interesting and also to establish scale. Working back and forth between the background layer and the robot, tighten up and detail the entire painting. Pay particular attention to edges. Avoid making consistent edges; make some edges sharper and others softer. Use the *Eraser tool in Brush mode* to help.

---

### photoshop close-up:

## TEXTURES

I used these samples from my library of textures to get the look of metal stains on the robot.

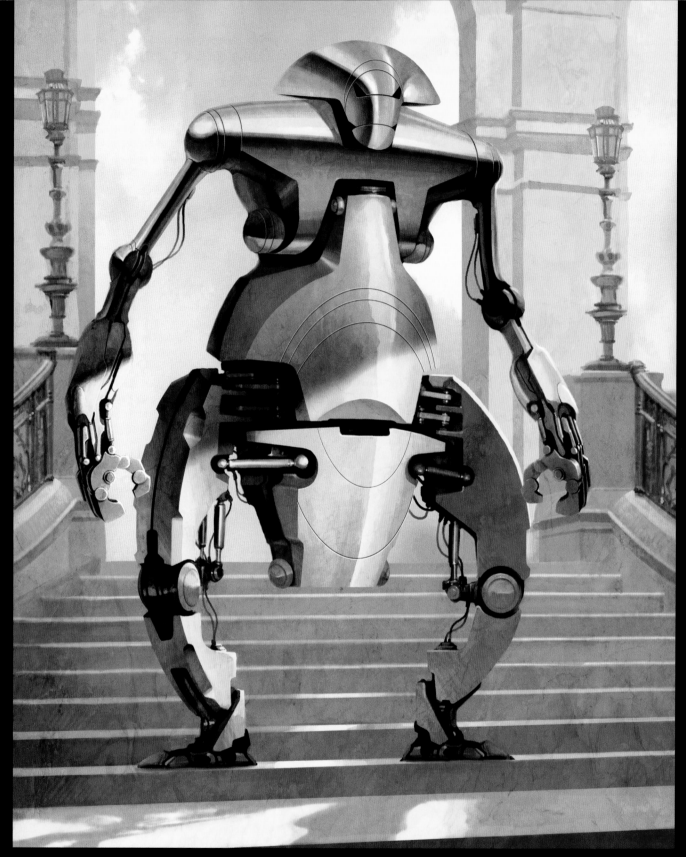

## STAGE 9 Finishing

I added a shadow over the top portion of the robot to make the lighting dramatic. Here's how to do it: Set the Lasso tool's Feather value to 10 pixels, then select the upper portion of the robot. From the Image menu, choose Adjustments, then Levels, and lower the levels to darken the area. With the same area selected, punch up the color saturation by going to the Image menu and choosing Adjustments, then Hue/Saturation.

## racer a

Sketching and planning are critical when designing vehicles. Slight errors are more noticeable since most people know what a car should look like. For this demo, I will illustrate how to design and paint using the computer to create a finished concept. The goal is to create a retro-style science-fiction racer with hover technology by mixing vehicle aesthetics from different eras.

**SURFACE**
Premium white 28-lb. (105gsm) color copier paper, 11" × 17" (28cm × 43cm)

**OTHER**
8-inch (20cm) 45°/90° plastic triangle with inking edge
Blueline pencil
Computer with Adobe Photoshop
Fine-tip black pen
White vinyl eraser

**STAGE 1** Blueline Sketch
Begin by drawing an old-style, open-cockpit Grand Prix Racer, updating the look with jet engines.

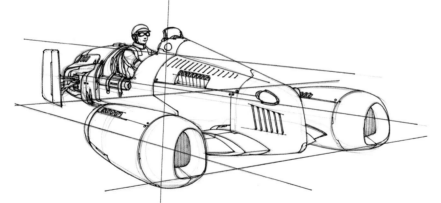

**STAGE 2** Defining Lines
Using the pen and triangle, place the more precise perspective lines, then begin detailing the driver-pilot.

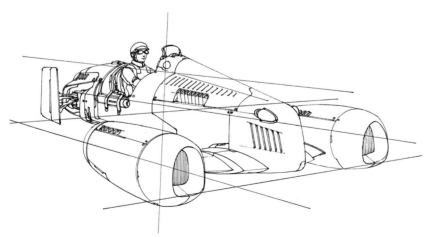

**STAGE 3** Complete Line Drawing
Erase the pencil lines and double-check the drawing for any perspective errors. Looking at the drawing in a mirror will help you spot any problems.

**STAGE 4** Scanning and
Beginning the Background

Scan the line drawing, then open the scan
in Photoshop and paint in the background.
Using the *Zoom Blur filter*, blur the
background to create motion blur and an
impression of speed.

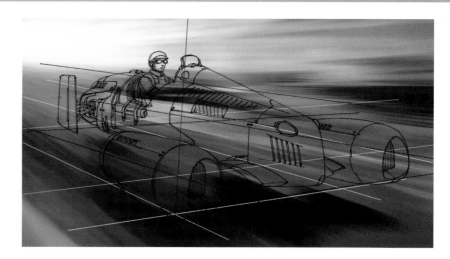

**STAGE 5** Blocking In the Racer

Create a new layer, then begin blocking in
the local color for the racer. Rough in the
form using the line drawing as a guide (I've
temporarily hidden the drawing layer here; see
Create a New Layer, page 43). Begin to paint
the form with reflections.

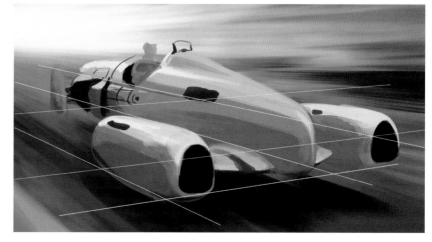

**STAGE 6** Further Refinements

Use the hard and soft brushes with default
Brush settings to continue adding details.
Begin the vents and other automotive details.
It's important to keep referring back to the
original line drawing.

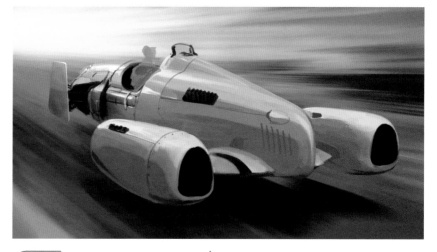

PHOTOSHOP FUNCTIONS

**ZOOM BLUR FILTER**

In the Layers palette, click on the layer you
would like to affect. From the Filter menu,
choose Blur, then Radial Blur. Pick Zoom
from the blur method and move the slider to
control the amount.

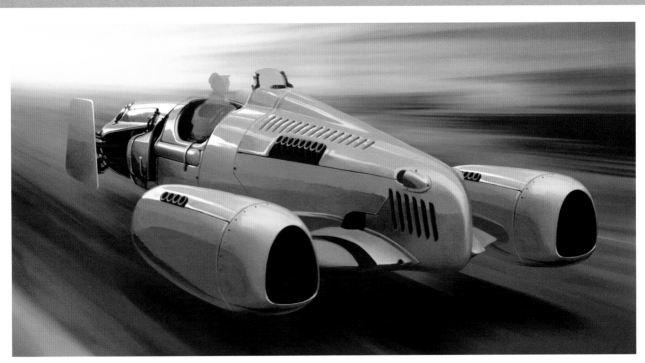

## STAGE 7 Continue Painting

Copy and paste the front engine and cowling and use them again for the far engine. This saves time. Add highlights and reflections to define the body of the racer.

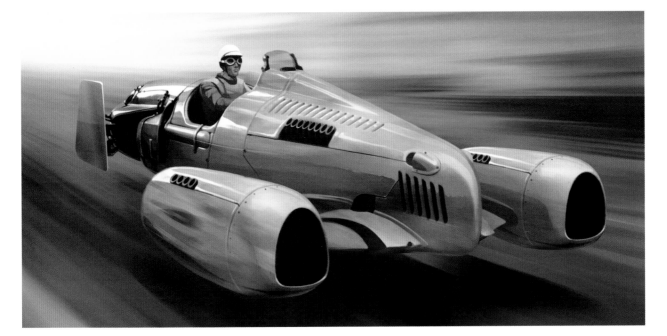

### REFLECTIVE SURFACES

Study real reflections on cars and chrome surfaces to learn how these reflections work. Chrome reflections are often compressed and stretched horizontally, creating a characteristic strong horizon line. You can see this line on the Racer A's engine cowling and the nose of the body.

## STAGE 8 Layer Trick

Make a copy of the entire painting, blur the copy with the *Zoom Blur filter*, and layer this "new painting" back over the original racer painting using a new layer in Soft Light mode. This creates blurred reflections and makes the car surface look more real without additional manual painting. To fine-tune this effect, adjust the color and opacity of the layer and digitally erase portions that aren't working.

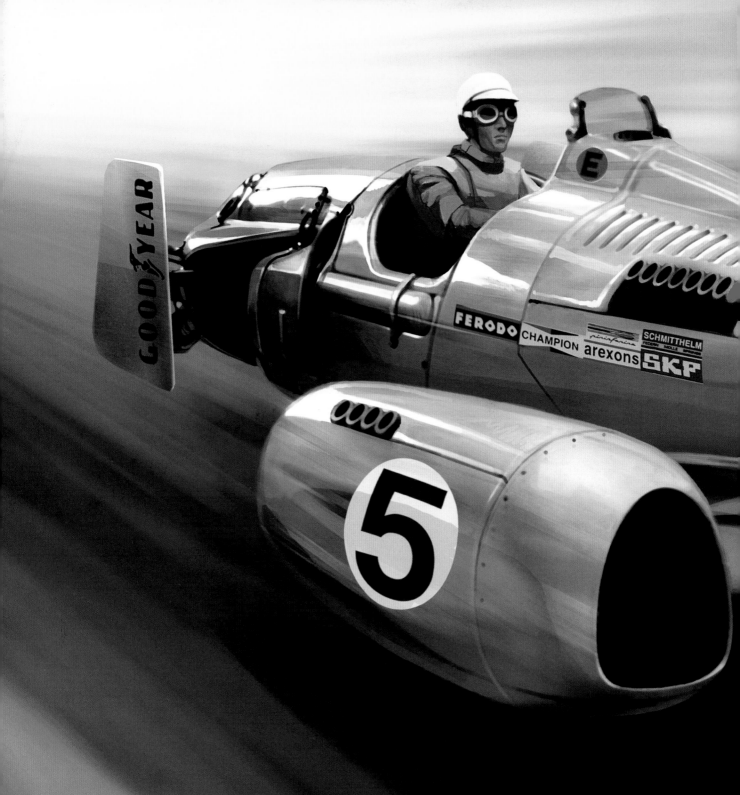

## PHOTOSHOP FUNCTIONS

### DISTORT AND WARP

With the Lasso tool, select the area you would like to distort. From the
Edit menu, choose Transform, then select either Distort or Warp. A set
of control points will appear over your image. Click and grab the control

**STAGE 9** Final Details

As a finishing touch, scan in various racing logos and paste them on the racer. Use *Distort* and *Warp* to adjust the perspective of the logos to make them fit on the car properly. The racing number was made the same way except that I typed it on the computer instead

# twin-wing attack fighter

**SURFACE**
Premium white 28-lb. (105gsm) color copier paper, 11" × 17" (28cm × 43cm)

**OTHER**
8-inch (20cm) 45°/90° plastic triangle with inking edge
Blueline pencil
Computer with Adobe Photoshop
White vinyl eraser

Sometimes concepts need context to make the design look complete. In this demo, we'll design a twin-wing fighter plane in a simple setting.

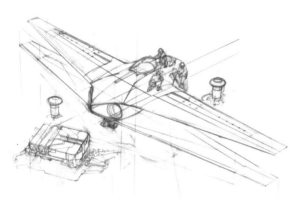

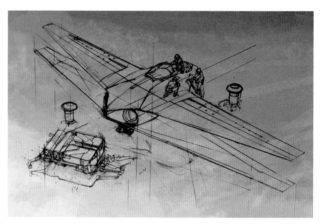

**STAGE 1** Blueline Sketch

Work out the design at full size with the blueline pencil on color copier paper. You don't need to figure out all the details now; the design can evolve as you paint.

**STAGE 2** Scanning and Background

Scan the line drawing into the computer, open it in Photoshop, and begin blocking out the background. Here I used gray earth tones to represent a dirty hangar floor.

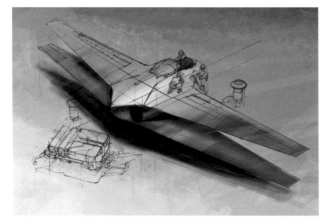

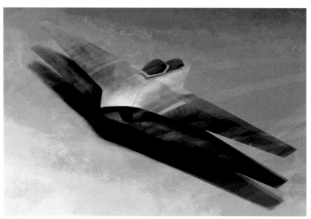

**STAGE 3** Masks and Color Block-in

Following the line sketch, mask the upper and lower wing shapes using the Lasso tool. (See page 72 for instructions on creating and saving masks.) It's a good idea to save all your masks so you can use them later. Then, using soft and hard brushes, paint into these masks to block in the wing colors.

**STAGE 4** Texture Layer

Find an old digital painting or photograph with interesting abstract color patterns. Copy and paste the image into your twin-wing fighter painting. Then, to mix the pasted image into the painting, set the pasted layer to Soft Light mode and adjust the layers colors (Image menu, then Hue/Saturation) and opacity to get the right amount of texture. Experiment to find the right balance.

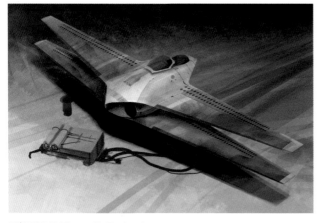

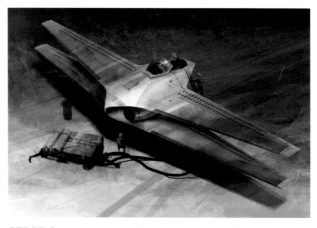

**STAGE 5** Detail Painting

Add wing markings by creating masks and painting into them. Create variations on the body panel by selecting areas you want to darken and lightly painting into them. Repeat for the other panels.

**STAGE 6** More Painting Refinements

Punch up the broad highlight on the body of the plane using the Brush tool in Color Dodge mode (see page 43). Enhance the smaller highlights on the engine intake cowling using the same brush. Don't forget to use your saved masks to contain the highlights (see page 72 for instructions on retrieving a saved mask).

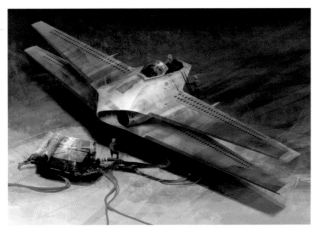

**STAGE 7** More Textures and Painting

Add more textures to the plane and background as you did in Stage 4, using the Soft Light layer mode and adjusting color and opacity. Use your saved masks again to add texture to specific areas. If you don't have a saved mask, create a new one.

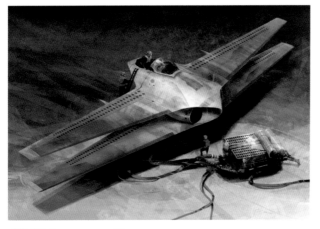

**STAGE 8** Almost Done

Flip the painting often as you work (Image menu, Rotate Canvas) to keep checking your progress. The painting should look good no matter how it's viewed.

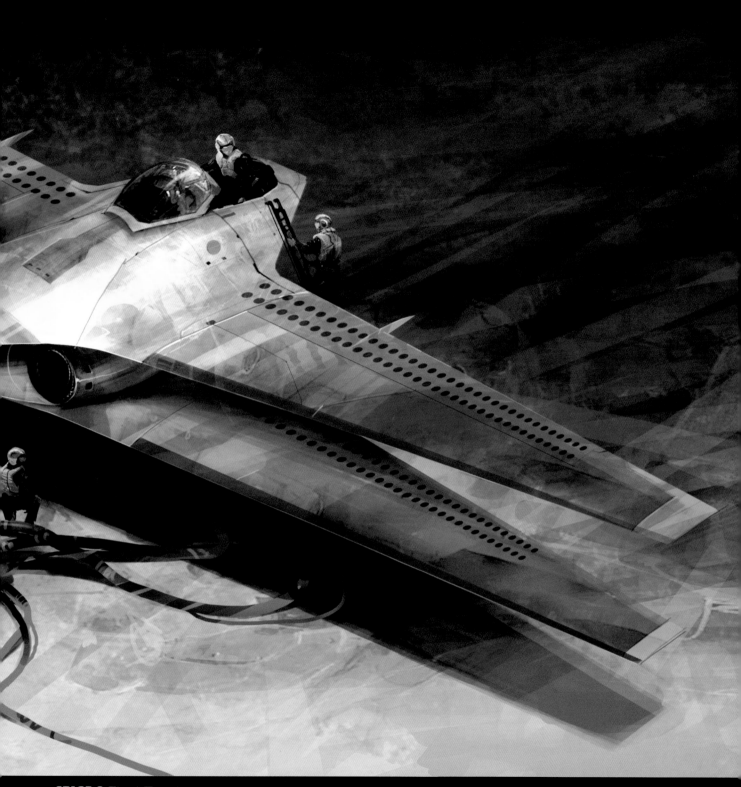

## STAGE 9 Final Touches

Add final highlights to the leading edges of the wings and the main body. These highlights will help determine the final form and focus the viewer's eyes on the centers of interest. Adjust the overall contrast of the painting to make the highlights even stronger. To adjust specific areas, use the Burn tool to darken areas and the Dodge tool to lighten areas. As a final touch, use the Hue/Saturation adjustment in the Image menu to boost the overall color saturation and make the painting punchier.

# air attack

In this demo, we'll create a scene that's more about dramatic presentation than design concept. You may recognize the twin-wing fighter from the previous demo.

**STAGE 1** Rough Sketch

With an idea in mind (here I was thinking of an aerial attack painting seen from the point of view of the attacking pilot), quickly rough in the key elements of the painting. Focus on the overall composition, and don't forget to keep all the paint elements on separate layers. Begin with three layers: the background, the twin planes, and the pilot. As the painting progresses, add more layers to keep new elements separate.

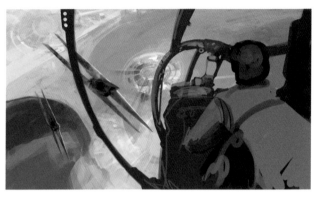

**STAGE 2** Preliminary Details and Textures

Roughly detail the main elements of the painting. Establish a spaceport on the ground (keep it vague, because it's distant) and gesture in some cockpit details. Don't worry about the specifics yet.

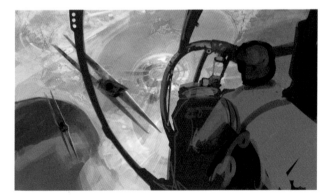

**STAGE 3** Background Texture

Find some aerial photographs of coastline features, and apply these images to the background using new layers in Soft Light mode (see page 43). This quickly adds detail and scale to the background. Merge these new layers with the background and paint over this to achieve the final result.

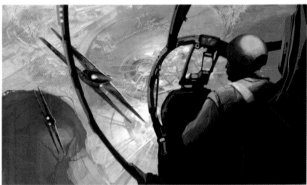

**STAGE 4** More Painting

With the background landscape nearly complete, work on the details of the two twin-wing fighters. Once the background is firmly established, move to the foreground cockpit interior. Refine the pilot and start designing the instrument panel.

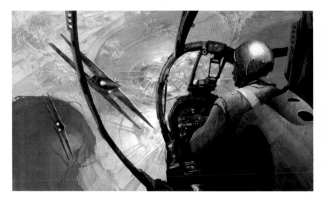

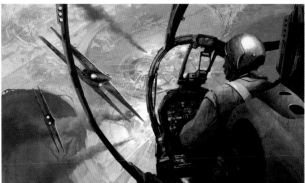

**STAGE 5** More Details and Textures

Working in different layers, continue detailing the instrument panel, designing as you go. (I decided I liked the loose quality of the instrument panel and chose not to finish it.)

Apply grit textures to the pilot and foreground seat using new layers in Soft Light mode. Add highlights and finishing touches throughout. Soft-light textures can "flatten" highlights so it's crucial to redefine them, especially on the edges of the helmet and foreground seats. Add these highlights and finishing touches to the centers of interest and leave the rest of the painting less refined.

**STAGE 6** Finishing

For more drama and action, paint in smoke and explosions using a combination of hard and soft brushes. (Study photographs of smoke to paint them properly. Keep files of reference images for this purpose.)

Because we know that smoke rises, the smoke columns provide a strong vertical cue and firmly set the pilot high in the air. We also know that we are diving into the ground, which heightens the drama.

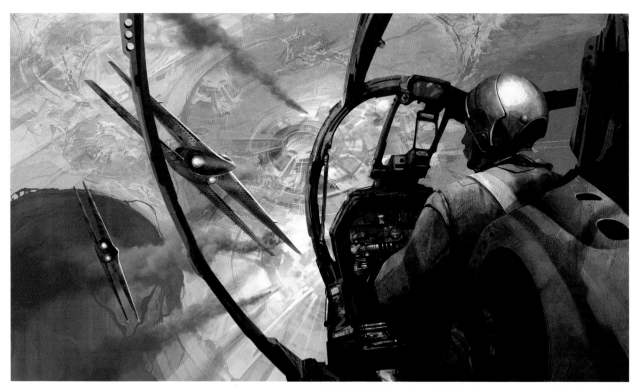

**STAGE 7** Shadow Effects

Using the Lasso tool with feathering and the Burn tool, add shadows for dimension and dramatic contrast.

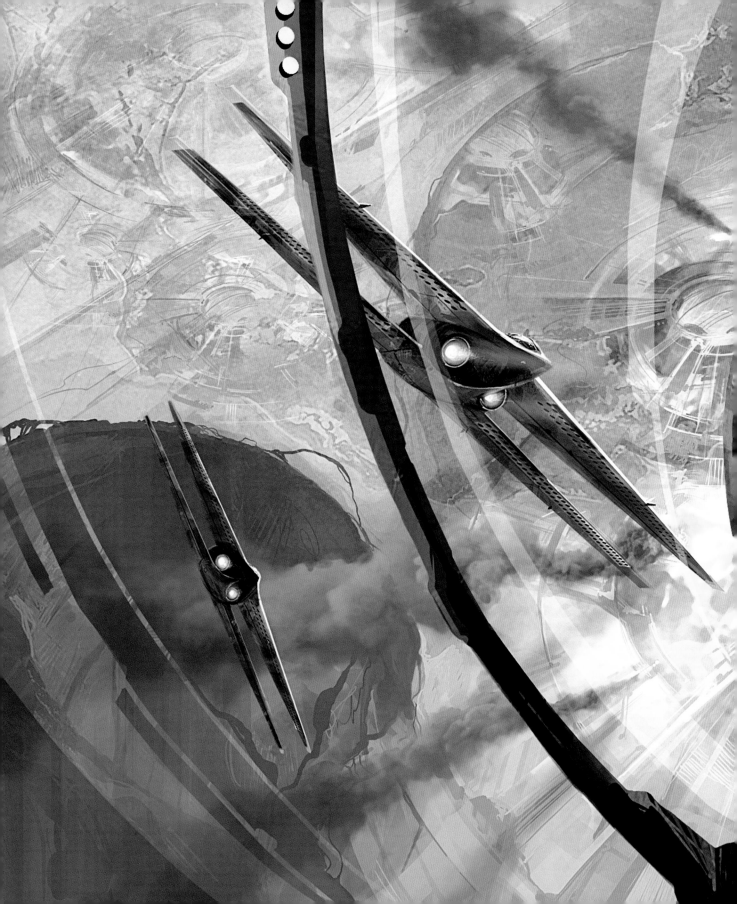

**STAGE 8** Highlights and Reflections

As a finishing touch, add window reflections by masking and painting
abstract shapes on a separate layer set to 50% opacity. Then punch up
the foreground highlights using the Brush tool in Color Dodge mode.

# R attack

Painting epic battle scenes presents unique challenges. The drama of the moment is paramount, so determine the location of the main action before proceeding. These scene paintings are about action. Crop into the composition or tilt the design elements to emphasize the energy and action of the scene.

**SURFACE**
Post-it note pad, 3" × 3" (8cm × 8cm)

**OTHER**
Blueline pencil
Computer with Adobe Photoshop
White vinyl eraser

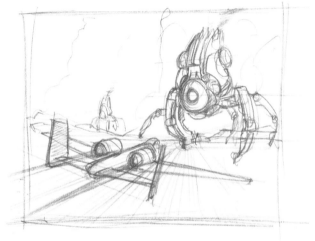

**STAGE 1** Rough Blueline Sketch

Using the blueline pencil, sketch a rough battle scene composition on a Post-it note. Use a simple diagonal layout. All the elements—the lines of the low-flying A-10 fighter, the walking robots, and even the smoke and atmosphere shapes—will support this composition.

**STAGE 2** Background Color Roughs

Create a new Photoshop document and start blocking rough colors for the background. Specific details aren't important yet. Your main goal is to work out the color palette.

**STAGE 3** Layout

Scan in the pencil sketch, paste it into your background color rough, and enlarge the sketch to fill the image area. Set the opacity of the sketch layer to about 20%, and then, working in the Background layer, rework the background as necessary to fit the scene design.

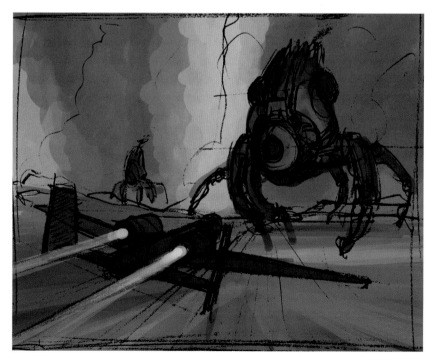

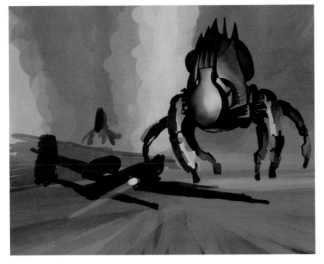

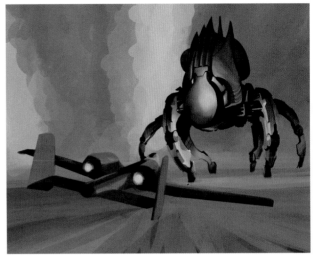

**STAGE 4** Blocking In the Robot

With the drawing layer temporarily hidden, start painting the attack robot. Use the leg concept from the Iron Robot (page 102) as a starting point. Reusing design ideas in this way saves design time and gives your work continuity (plus I really like those legs and wanted to try them for this robot).

**STAGE 5** Blocking In the Foreground

Using the Lasso tool, create and save an inverted mask (see page 72) in the shape of a silhouette of the fighter jet. Then paint inside the mask to begin blocking out the form.

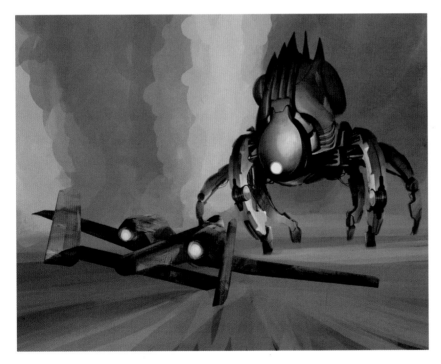

**STAGE 6** Texture Effects

Apply rough painted textures to the jet painting using the mask from Stage 5 to contain the texture. With just this simple addition, the jet looks almost finished.

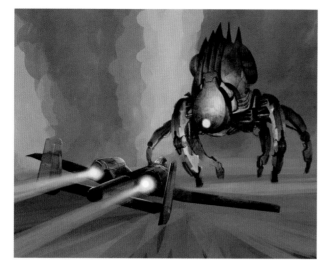

**STAGE 7** More Painting and More Textures

Paint highlights, a cockpit and engine exhaust (see page 95) to finish the jet. When you focus details in specific areas, a roughly painted element can look finished.

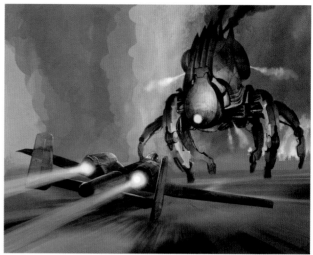

**STAGE 8** Smoke and Fire for Scale

Using a soft round brush with the default settings, paint in smoke and fire on a new layer. For added drama and speed, blur the ground in the foreground (see page 108).

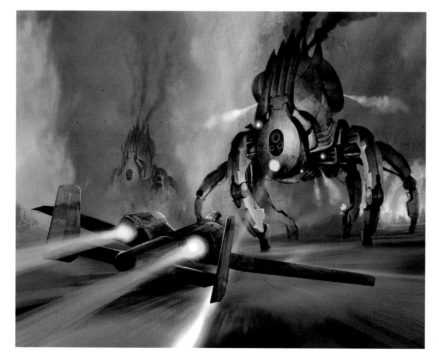

**STAGE 9** More Painting

Finish the smoky background using the soft and hard round brushes to create fuzzy smoke edges. For added edge effects, choose a brush preset with a coarse pattern from the Brushes palette. Click "Brush Tip Shape" and set the Spacing to 70%. Fine-tune with a hard round brush.

Copy the main robot and paste it into the background on a new layer. Scale down the second robot to fit, then adjust the layer's opacity and Hue/Saturation. Add smoke above the second robot.

Using the Brush tool in Color Dodge mode with a soft edge, select a blue hue, and paint in the ray beam. After creating the glow, set the brush back to a standard hard edge (but keep it in Color Dodge mode) and paint in the white lightning that makes up the core of the ray beam. The bright blue-white beam complements the yellow-red jet exhaust and reinforces the diagonal composition.

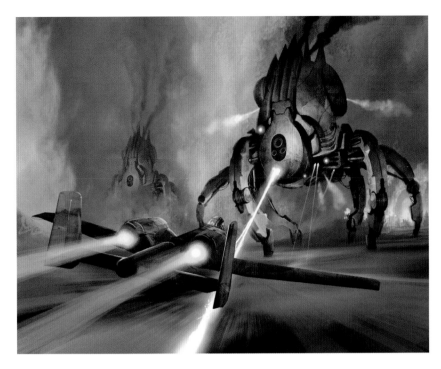

**STAGE 10** More Ray Effects

Still using the Brush tool with a hard edge in
Color Dodge mode, finish the ray beam.

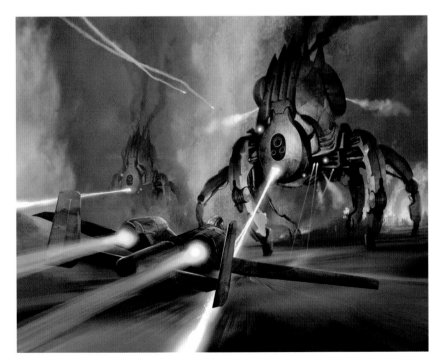

**STAGE 11** Dodging and Burning

Begin to balance and fine-tune the values of
the different elements in the painting using the
Dodge and Burn tools. For example, darken
the top of the robot while lightening the area
around the beam.

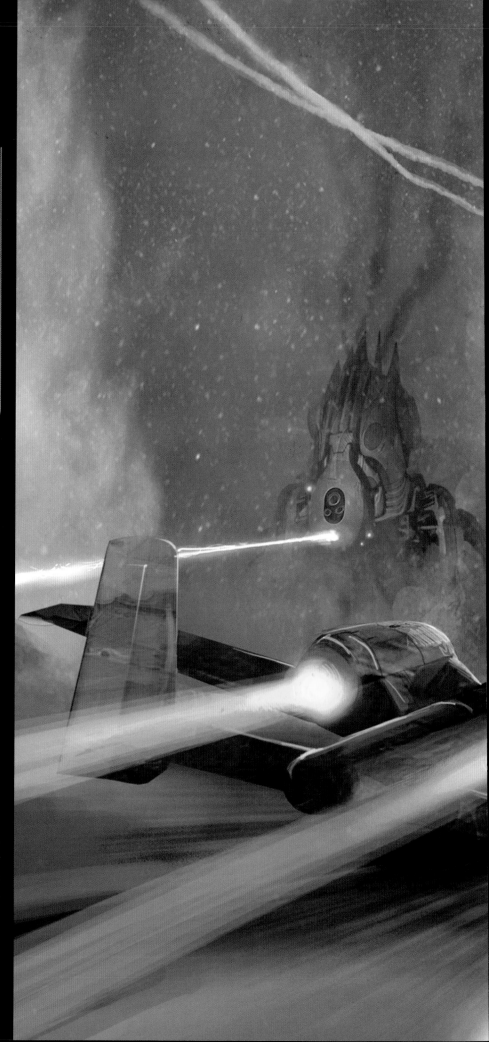

## PHOTOSHOP FUNCTIONS

### CREATING RANDOM SPRAY PATTERNS:

Set the Brush tool to a small hard round edge. In the Brushes palette, first click "Brush Tip Shape" and set the Spacing to 1000%; then enable Scattering, checking "Both Axes" and specifying a Scatter value of 1000%. Use this brush on a new or duplicate layer to "spatter" paint random white dots (edit out dots as needed with the Eraser tool) to edit.

These brush settings mimic the traditional painting technique of dipping an old toothbrush in paint and scraping the bristles to create random spray patterns.

**STAGE 12** Finishing Touches

As a finishing touch, add some snowy ash to the sky with some *random spray patterns*. This gives the painting atmosphere and texture while also helping to blend together all the elements.

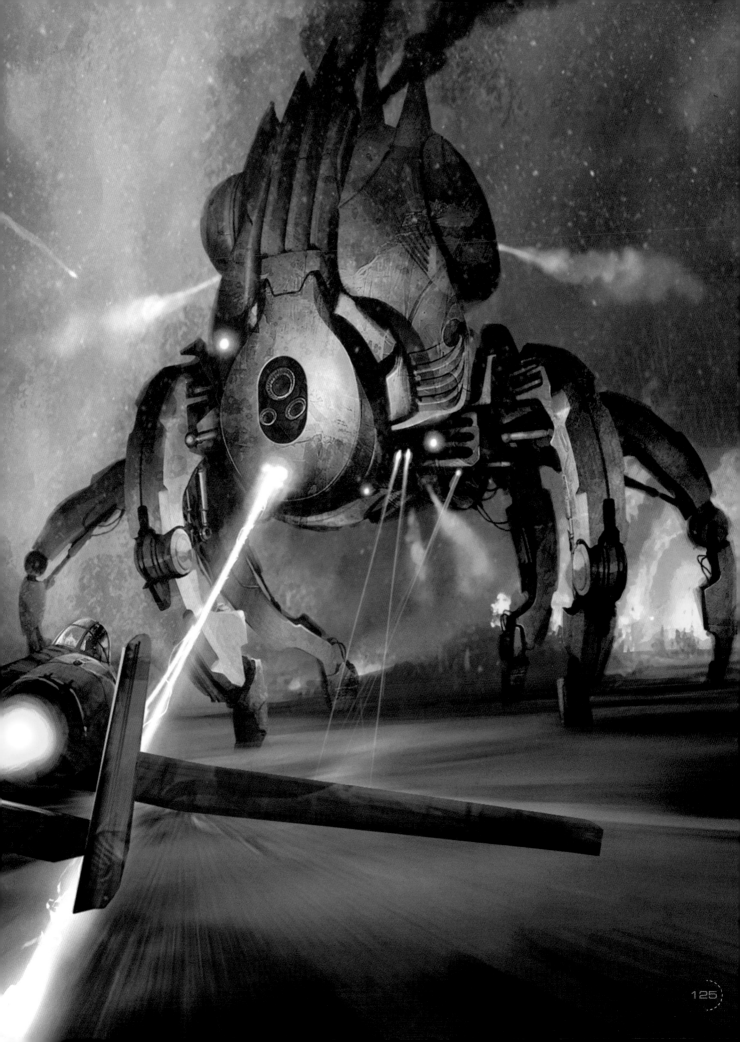

# crash

Designing as you paint is one of the great advantages of painting digitally.

Since digital painting allows you to continually edit and re-paint throughout the

process, you can start with just a mere suggestion of an idea.

**STAGE 1** Rough Color Sketch

Starting with the simple idea of a crash scene,
begin painting a color sketch. You don't need a
design or even a complete composition worked
out yet; this is purely exploration.

**STAGE 2** Having Fun and Details

At first, try not to worry about the details. Instead,
focus on the overall form. Since this is a crash
scene, you can be vague in the design of the jet.
Once you have the form, begin to figure out the
cockpit and the upper wing details. Focus your
attention on these two main areas of interest,
and leave the rest of the jet ambiguous.

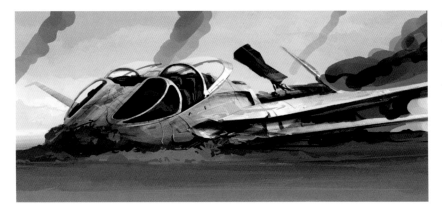

**STAGE 3** Designing With Paint

Working back and forth between the negative and positive shapes, begin to tighten up the jet. The back-and-forth painting process allows you to design without doing labor-intensive line sketches.

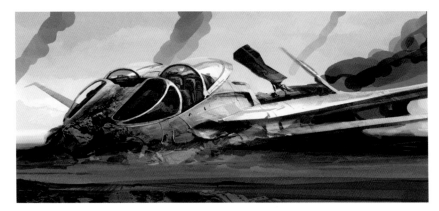

**Reference Photo for Stage 4**

Use photos of wrecked vehicles to give you realistic textures for your crash scenes.

**STAGE 4** Adding Textures and Foreground

Add dirt and crumpled-metal textures to the front of the plane. To do this, mask around the jet and layer photographs of twisted metal on top of the jet painting using the Soft Light layer mode. The photo layers add a level of detail that would be too labor-intensive to paint.

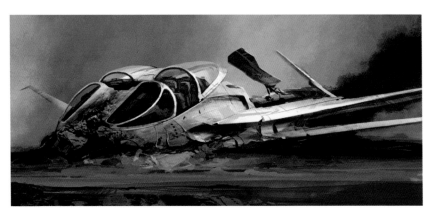

**STAGE 5** Background and Lighting

The drama of my scene wasn't quite working, so I replaced the blue sky with a dark, smoky, more sinister and foreboding sky. The darker background allows you to feature the dramatic lighting on the plane.

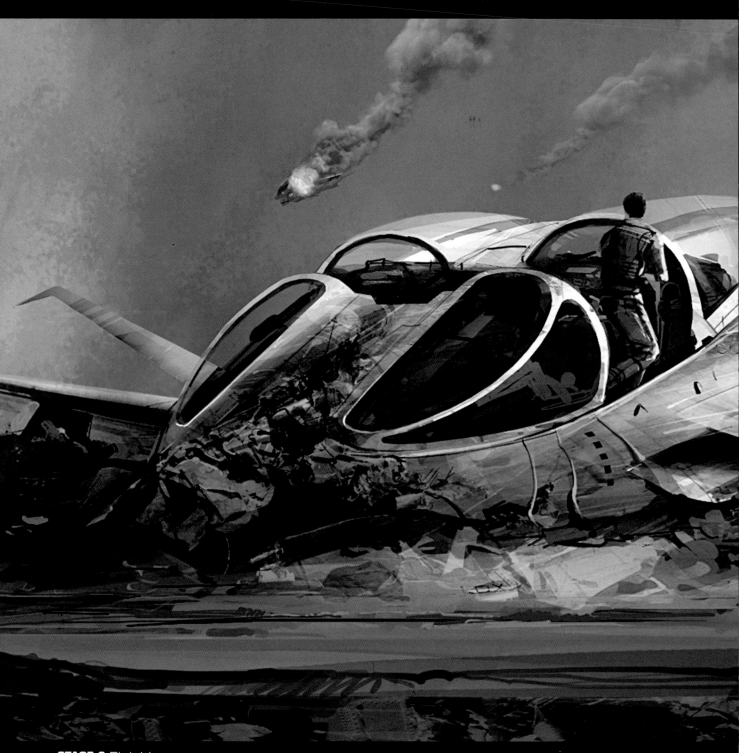

## STAGE 6 Finishing

Add a pilot and other vehicles to the background to heighten the mystery and drama of this scene. Paint in the pilot by first blocking in the figure's overall shape, then adding details and lighting to complete him. Sometimes it is helpful to sketch the figure on paper first, then scan and place the sketch into the painting. In this case, however, I just painted the figure from scratch directly into the scene. Refer to Simple Jet Blast or Engine Exhaust on page 95 for tips for adding the flaming ships and smoke in the background.

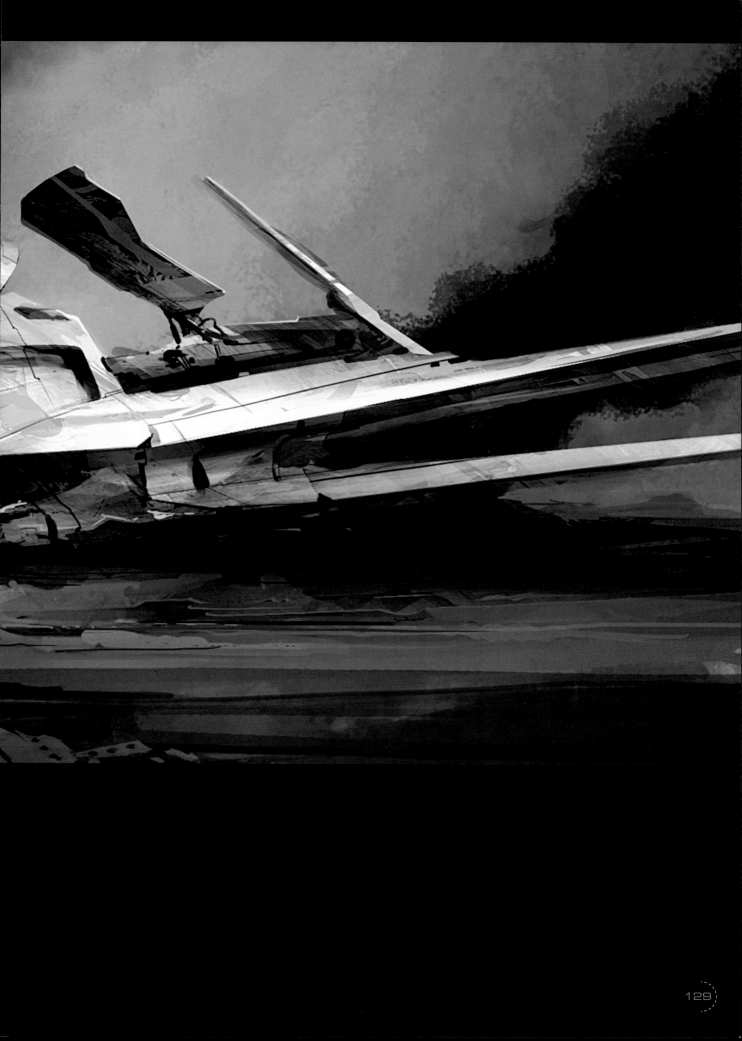

Computer with Adobe Photoshop

# desert fighting machine

It's not just scenes that can evolve as you paint. In this demo, you'll see how even complex fighting machines can evolve, beginning with only a vague concept and a very simple background, through multiple layers in Photoshop.

**STAGE 1** Setting the Background and Palette

Quickly rough in a simple ground plane with some cloud shapes. Make the color palette warm to suggest a desert.

**STAGE 2** Rough Sketching

Refine the background a little more. Then, loosely sketch in a robot form on a new layer using a hard round brush with default settings.

**STAGE 3** Blocking In the Robot

On a new layer, begin blocking in the robot design using only two values—a dark and a light—and the Brush tool with default settings. The darker value creates the shadows and allows you to design with volume instead of with lines.

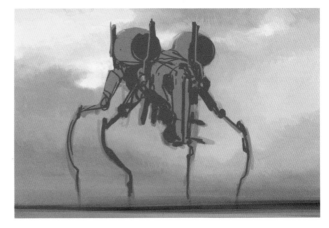

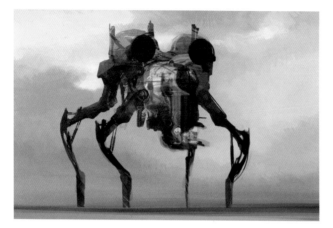

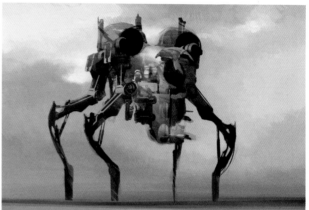

**STAGE 4** Strong Silhouette

With a good robot silhouette done, create a new layer, using the option, "Use Previous Layer As Clipping Mask." This will allow you to paint only within the robot shape and nowhere else.

**STAGE 5** Working With Masks

Using the Lasso tool, create hard-edged masks for highlight areas. For the legs, I referenced the Steambot design (page 50). Saving these masks will allow you to continually paint into just the selected highlight areas as you progress. Create masks for all the different parts you want to define. (See page 72 for more detailed instructions on creating, saving and retrieving masks.) Once you've created all the masks, use them to paint the highlights.

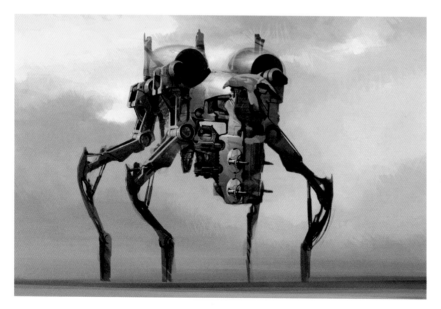

**STAGE 6** Working in Layers

Create a new layer. In the Layers palette, drag the new layer below the highlight layer. Now, with the highlights on a top layer, paint the body details into the layer below the highlights. This will allow you to define the body paint without affecting the previously painted highlights.

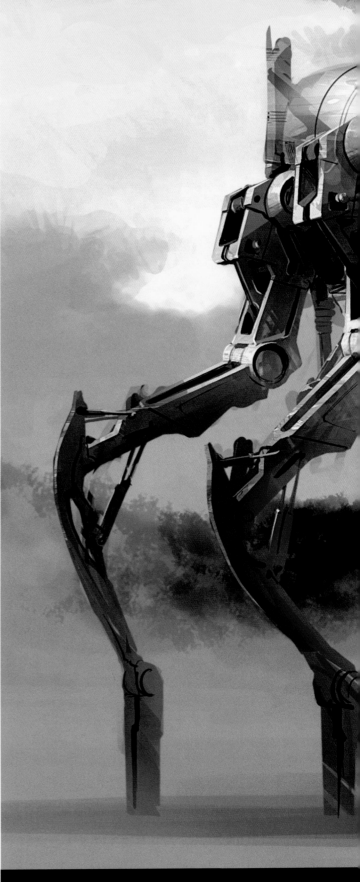

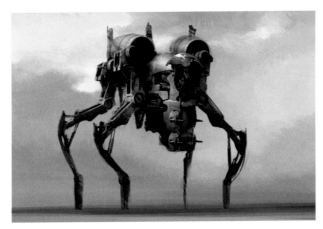

### STAGE 7 Shadows and Form

Using the Burn tool, begin giving shape and volume to the painting by darkening the robot's shadow areas.

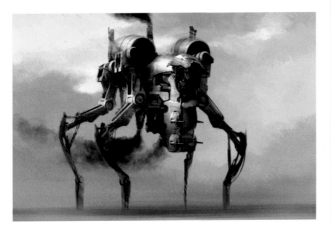

### STAGE 8 More Dodging and Burning

With the Dodge and Burn tools, continue painting shadows and enhancing highlights. In addition to defining form, this lets you create lighting on the robot without extensive repainting.

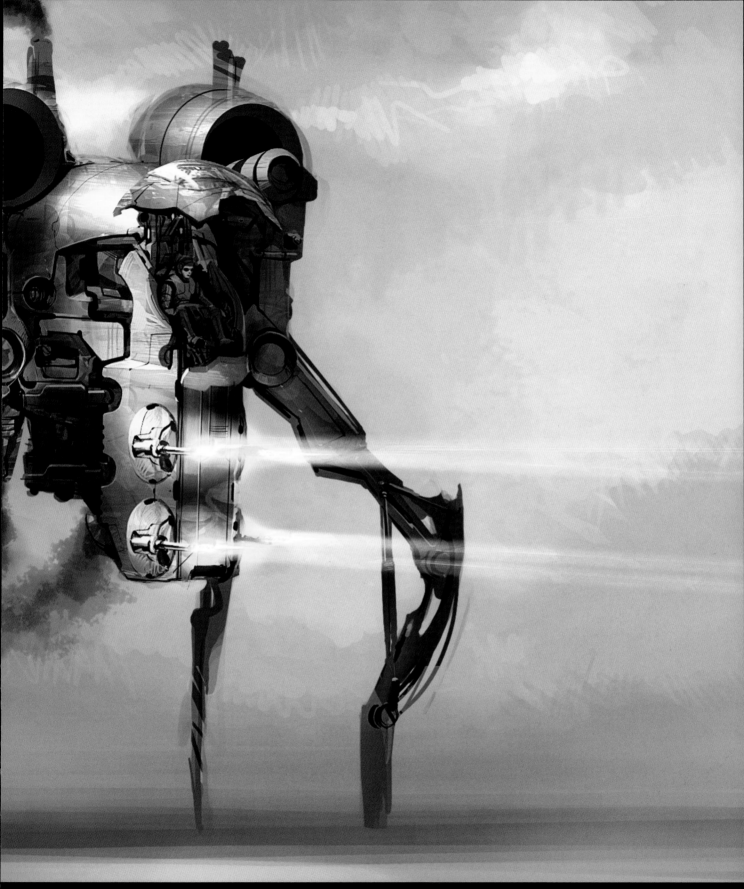

**STAGE 9** Finishing Touches

Finally, using the Brush tool in Color Dodge mode, paint in
gun blasts. Add lighting on the robot and the ground using

# standoff

Combining a nineteenth-century Tall Ship with a hi-tech robot instantly creates drama and story and makes for a unique painting. This is one of my favorite juxtapositions of imagery.

**SURFACE**
Post-it note pad, 3" × 3" (8cm × 8cm)

**OTHER**
Blueline pencil
Computer with Adobe Photoshop

**STAGE 1** Thumbnail Sketch
Roughly sketch a crablike robot on a Post-it note and scan it into the computer.

**STAGE 2** Rough Color Blocking
Open the scanned sketch in Photoshop. On a new layer, use the Pencil tool to sketch in a Tall Ship, the horizon line, and a few perspective lines. Once you're happy with the composition, block in simple background colors on another new layer.

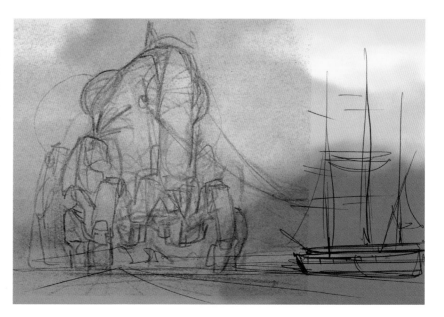

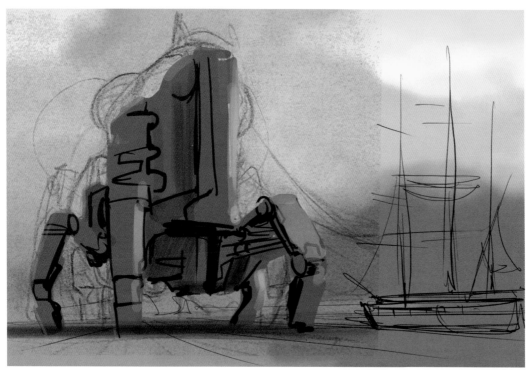

**STAGE 3** Blocking In the Robot

Block in the robot on a new layer, then use the Eraser tool in Brush mode to further refine the
robot silhouette, cutting away to create a more angular, aggressive shape.

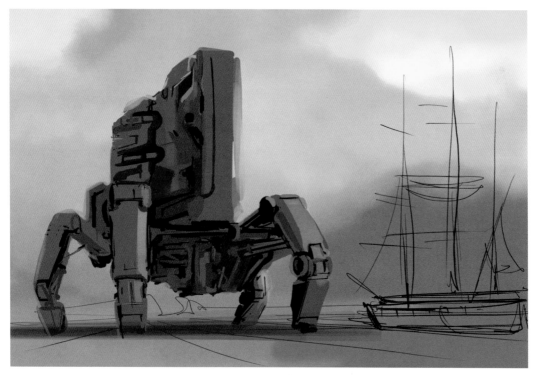

**STAGE 4** Designing the Robot

Discard the layer containing the robot thumbnail sketch. Start refining the robot using three
values: highlight, midtone and shadow.

**STAGE 5** Painting by
Grouping Layers

Select the rough robot layer in the Layers
palette. Then, create a new layer and check
"Use Previous Layer to Create Clipping
Mask." On this new layer, you will be able to
paint only into the robot silhouette. Create
random mechanical shapes to imply details.
Focus primarily on overall impression and not
on exact details. Create another new layer (no
mask this time), then base in the Tall Ship.

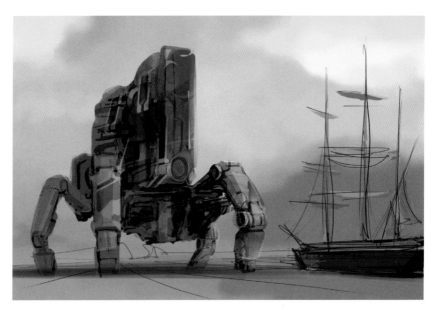

**STAGE 6** Highlight and
Shadows

On another layer, begin painting highlights
throughout. This starts pulling the form
together. On yet another layer, paint only
shadows.

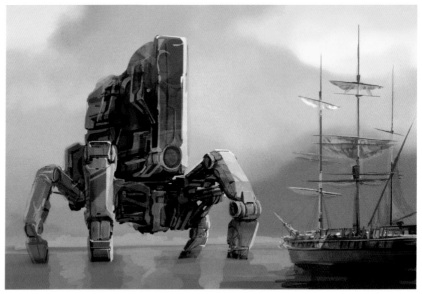

**STAGE 7** Further Refinements

Copy all the painted layers of the robot and
merge them into a single layer. Working on
just this new merged layer, begin additional
detail painting. For example, add highlights
and refine the reflections of the water and the
ship's hull, and add a highlight to the robot's
leg where it touches the water to define its
spatial relationship to the ship.

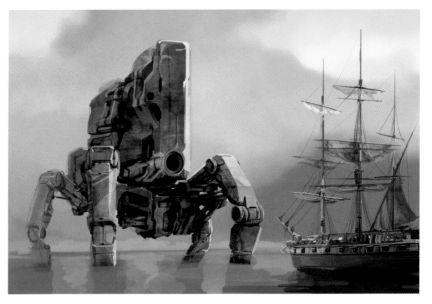

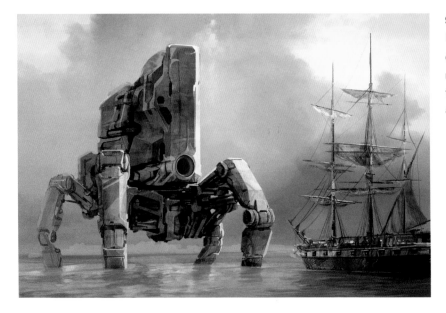

**STAGE 8** Textures and Background

Create a new layer in Soft Light mode over the robot layer, then add texture effects. Refine the background, water and ship in this way as well.

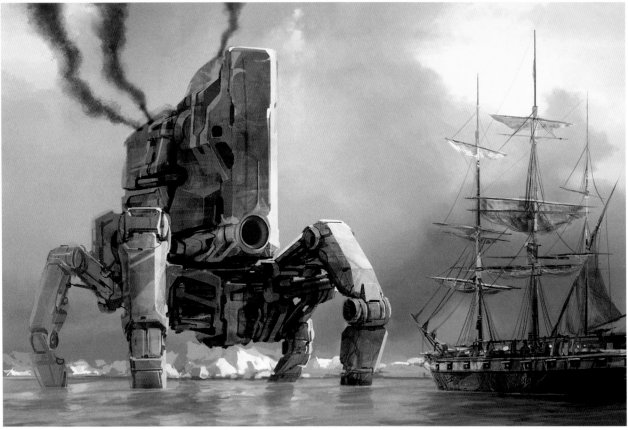

**STAGE 9** Balancing the Elements

With the painting nearly complete, make adjustments to the values of the robot to balance it with the background and the Tall Ship, making sure all the pieces are fitting properly into the scene. Blur and erase parts of the back end of the robot to better integrate the robot with the scene.

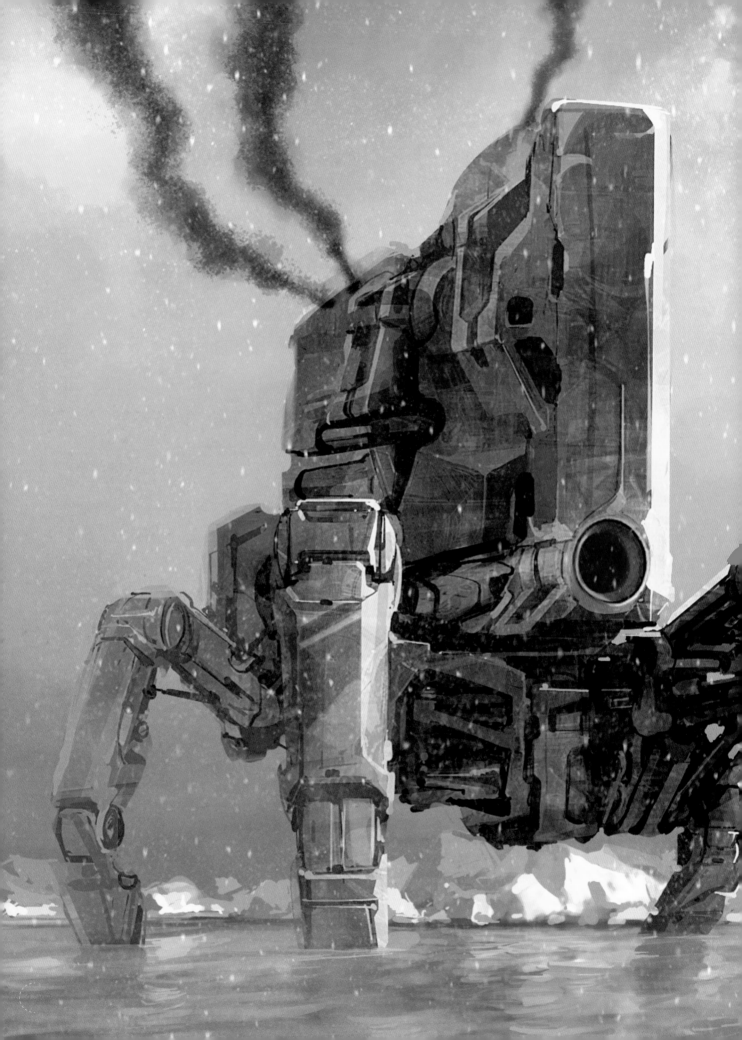

**STAGE 10** Finishing Touches

Finally, add atmospheric smoke, haze and falling snow to tie the whole scene together. Punch up the highlights on the robot using the Brush tool in Color Dodge mode.

# A LAST WORD

I'm often asked how much time I spend on a drawing or painting. That's a tough question to answer since there are so many variables. Sometimes an idea comes to me right away. Other times, I'll chase it for days, if not weeks.

Most, if not all, of the marker sketches in this book were completed in three hours or less. I find that to be a good pace for me; otherwise, I risk overworking the drawing. The digital paintings took about two to three days each to complete. Don't be concerned if your marker sketches or paintings take longer than mine. There are many artists who work much faster than I do, and some, much slower. It's not a race. The end result is what matters most. When people see your work, they will not be impressed by how fast it was completed, but they will care if it's done very well.

I hope that seeing and working with some of my techniques provides you with a glimpse into your own potential. And I hope you will be inspired to discover the vast variety of working methods available to you.

Use this book as a starting point to find your own style. Customize and adapt the techniques covered here as necessary. Build upon what you've learned here, and experiment. Most importantly, draw, and draw a lot.

Practice will refine your skills until they become second nature. When this happens, you'll be able to focus on ideas and not execution. That's when the fun really begins, and you won't be thinking about speed at all.

## BASIC PORTFOLIO TIPS

Over the years, I have reviewed many portfolios. The ones that stand out are always the ones that clearly demonstrate the artist's firm grasp of the fundamentals.

### SELECT

Start by selecting approximately thirty-six of your best pieces. These should accurately reflect your skills. Then, depending on the job or position you are seeking (see "Target," below), trim this selection down to about twenty-four. Ask a friend or a peer for help in the trimming process.

A solid portfolio requires tough self-examination. Sometimes an artist can become emotionally attached to a poor piece. Objectivity is paramount when making the final selections. If you are not sure, leave it out or put it into a supplemental portfolio.

### ORGANIZE

Once you've honed down your selections, organize your portfolio by placing your second-best piece in the front. Next, put in your weakest piece and then progressively move towards your strongest, ending with your best piece.

Make your portfolio easy to review by keeping all your pieces oriented the same way so the reviewer doesn't have to rotate the book to look at your art.

### TARGET

Target your portfolio for the job or work you are applying for. If you are applying for vehicle design, it's not necessary to put in creature work. A few creatures are OK to show the breadth of your skill, but edit out the pieces that don't apply. For this reason, it's a good idea to make several portfolios: one for creature design, one for finished paintings, one for vehicle design, etc.

### FOCUS

As your skills develop, begin focusing on one specific area of interest. Whether it's machines or creatures, decide what you want to do and work at being the best in that discipline. Entertainment design is very competitive, and it's better to excel in one area than to be mediocre in many. Art positions are often cast like actors for a movie. Specific skills are sought and the best candidate with that skill is hired.

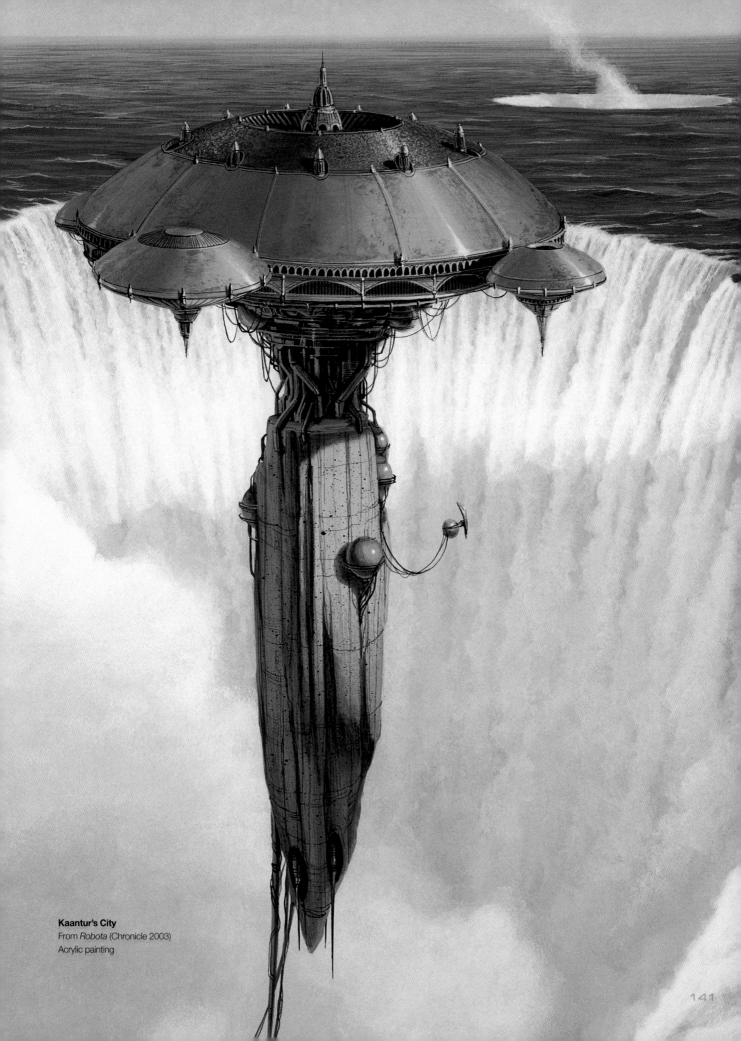

**Kaantur's City**
From *Robota* (Chronicle 2003)
Acrylic painting

141

# index

**ISBN-13:** 978-1-60061-010-3
**ISBN-10:** 1-60061-010-2
Paperback, 128 pages, #Z1044

Discover the creative processes and intriguing inspirations behind the work of leading fantasy artist John Howe in his first-ever practical art book. From creatures and beings to atmosphere and landscapes, uncover John Howe's art of myth and legend, then create your own.

These books and other fine *IMPACT* Books titles are available at your local fine art retailer, bookstore or online supplier. For more information, visit our website at www.impact-books.com.

**ISBN-13:** 978-1-58180-992-3
**ISBN-10:** 1-58180-992-1
Paperback, 160 pages, #Z0939

This is the definitive book on digital coloring for amateurs and professionals alike—from comic book fans and Photoshop whizzes who want to color for the fun of it, to colorists looking to perfect their skills, to graphic arts professionals in search of something new to offer their clients.

**ISBN-13:** 978-1-60061-000-4
**ISBN-10:** 1-60061-000-5
Paperback, 128 pages, #Z0989

Open this book and enter a realm where human warriors coexist with giants, monsters and many other mythical creatures both mundane and magical, all battling for survival.

Four artists who have dared to venture this way before (and won reputations as masters of fantasy illustration) are here to lead you through this wicked world, sharing their fiercest techniques for creating your vilest imaginings.